HADRIAN'S WAY

Creating World Monuments Fund 1965–2015

MARILYN PERRY
Chairman, World Monuments Fund, 1990–2007

Cover: *Siem Reap, Cambodia.* Angkor Archaeological Park. The central axis and Hall of Dancers at the twelfth-century temple complex of Preah Khan, conserved by WMF as a partial ruin. Work at the site is ongoing.

Copyright © 2016 by Marilyn Perry

All rights reserved

No part of this book may be reproduced, stored in a retrieval system, or transmitted by any means—electronic, mechanical, photocopying, recording, or otherwise—without written permission from the copyright holder.

ISBN 978-0-9903322-2-0

Dedicated to

Col. James A. Gray
Founder, 1965–1984

and

Bonnie Burnham
Executive Director, 1985–1995
President, 1996–2015

who led us on the way.

Without the monuments of the past, we wander lost on the sands of time.
—Armenian proverb

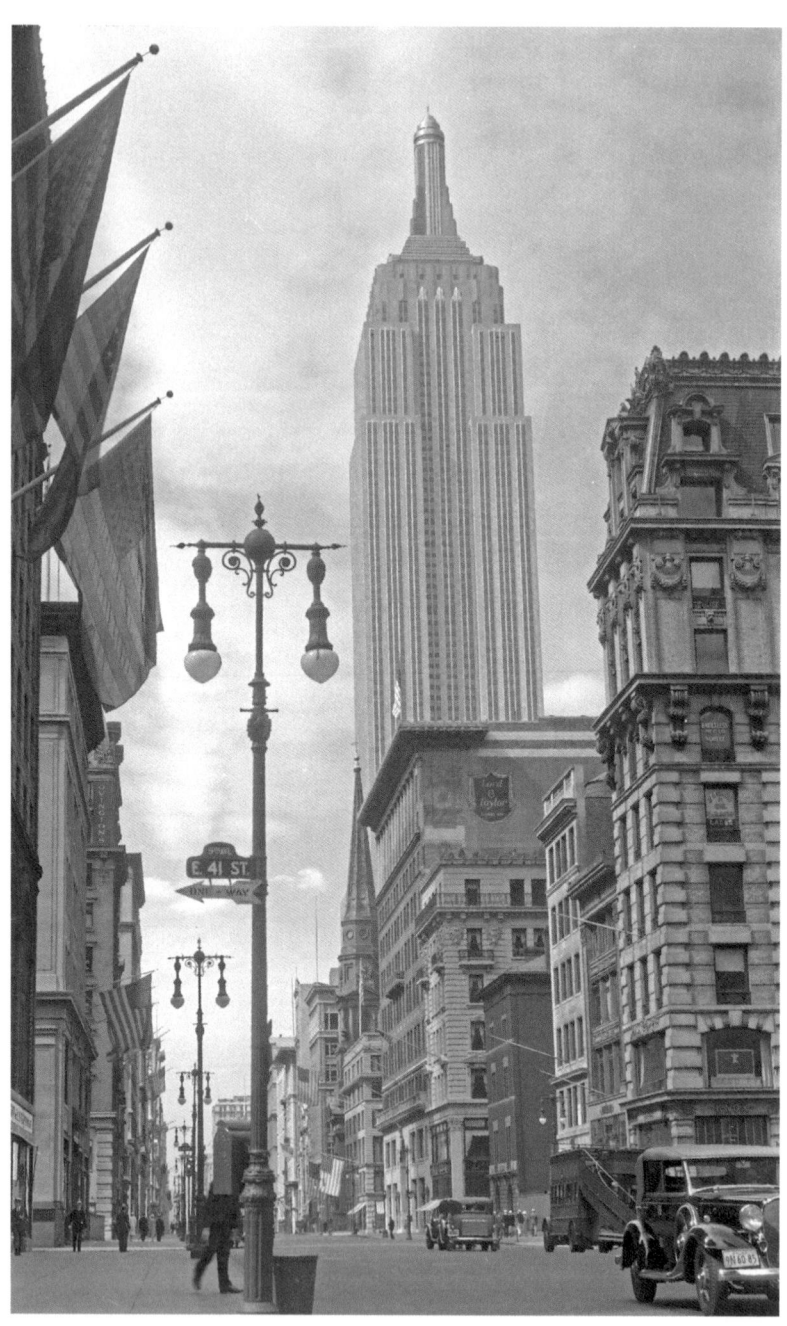

New York City. World Monuments Fund is headquartered in the Empire State Building (vintage photo from 1933).

Walk into the headquarters of World Monuments Fund (WMF) on the 24th floor of the Empire State Building in New York City and you find a busy staff of around 30 people in smart cubicles and offices with computers and bookshelves, a large windowed boardroom, a library and archive, a kitchen, and wide views of Manhattan to the north and west. Around you on the walls are beautiful oversize images of ancient sites, architectural ruins, man-made landscapes, and exotic faraway buildings—places where WMF has made a difference over the past 50 years.

This thriving, dedicated organization now leads the private sector response to preserving cultural heritage around the world. This was far from likely at its founding in 1965, and the story of its evolution is a great adventure involving vision, determination, need, opportunity, timing (and sheer blind luck) on the way to creating something new—the world's first professional international preservation organization.

As an active player in most of this history, I report from my memories. Here, then, is a personal record of people and ideas, of remote and beautiful places and serious challenges, of hard won successes and many good times, on a long and eventful road that opens both forward and back in time.

Col. James A. Gray (1909–1994), Founder of the International Fund for Monuments, on site in Lalibela, Ethiopia, ca. 1966.

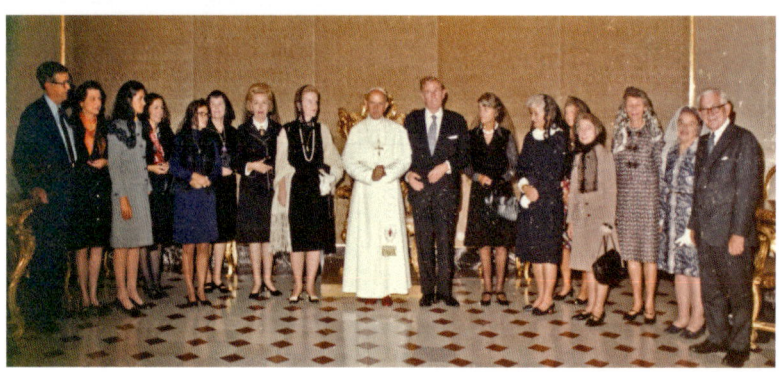

IFM donors in an audience with Pope Paul VI in 1969.

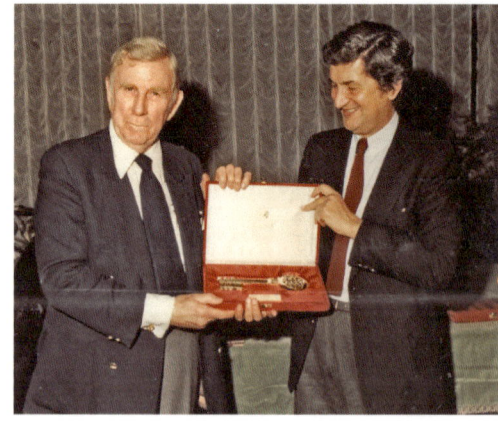

Col. Gray receiving the Key to the City of Venice from Mayor Mario Rigo in 1979.

1965–1985

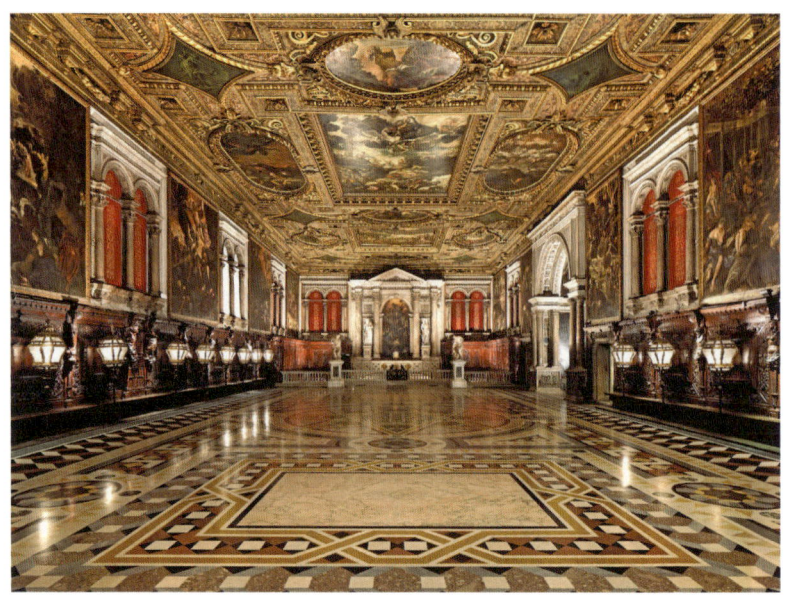

Venice, Italy. The Sala Superiore of the Scuola Grande di San Rocco. All 38 paintings (1564–87) by Tintoretto were restored by IFM in the 1970s.

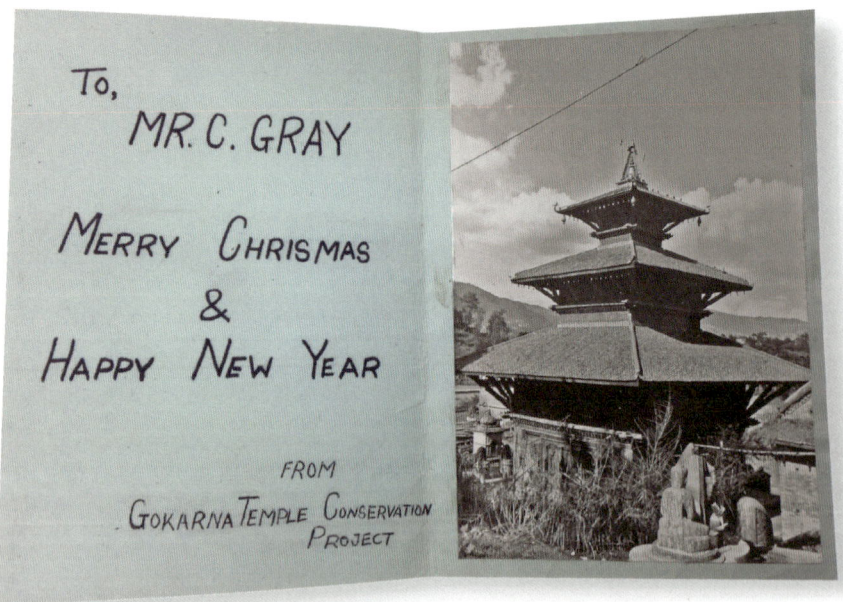

A greeting card to Col. Gray from the Gokarna Temple Conservation Project, *Kathmandu Valley, Nepal,* 1979.

THE CHALLENGE
International Fund for Monuments

Could it be done? The need was obvious and compelling, the means uncertain at best. Would it be possible both to imagine and then structure a professional non-profit agency to respond to endangered architectural heritage throughout the world? To establish an entirely new kind of international preservation organization? In 1984, a small group gathered around a heavy table in a dark, paneled room in New York City to focus on how to make the International Fund for Monuments just such an organization.

INTERNATIONAL FUND FOR MONUMENTS, INC.

The Founder, Col. James A. Gray

International Fund for Monuments (IFM) was a visionary enterprise with a grand ambition and impressive achievements that rested entirely on the shoulders of its founder, a retired American Army colonel from San Francisco named James A. Gray, who now in 1984, aged 75, had decided to step down. In the wake of his pending retirement, the question on the table was how to shape the future of IFM and advance the work of the organization's first 20 years.

The story was one of American energy and initiative. In the mid-1960s, still vigorous and rather bored, Jim Gray stayed on in Italy at the end of a long and active military career (including wartime service as a paratrooper), and looked around for something useful to do. The physical deterioration of famous monuments—especially the Tower of Pisa—caught his attention. UNESCO and other agencies confirmed a glaring need for support from the private sector. The Colonel recruited a few like-minded friends and founded the International Fund for Monuments, an American non-profit organization, on the Ides of March in 1965. He was 56 years old.

For the next 19 years, it consumed his life. He not only raised the funds for projects, but also supervised the work, zealously guaranteeing the financial as well as the technical integrity of everything IFM funded and enjoying his contact with the architects and engineers on the sites. He lived on his military pension and covered IFM's low overhead by investing donor funds at high interest. Everything conspired to give Gray the active, engaged life that he relished, and IFM's first projects—accepted as they came along, if funding could be found—were far-flung indeed.

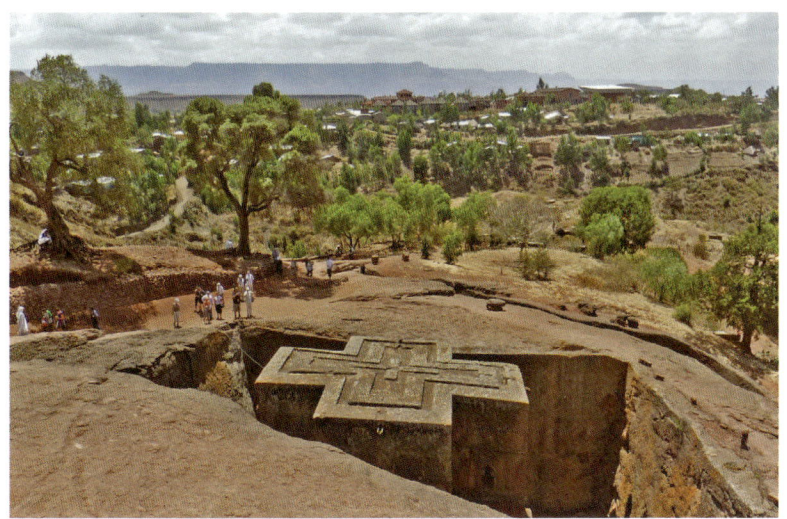

Lalibela, Ethiopia. One of the rock-hewn medieval churches at Lalibela, IFM's first project (1966–72).

THE FIRST PROJECT
Medieval Pilgrimage Churches in Ethiopia

Typical of these years was his very first project, proposed by UNESCO: an extraordinary but largely forgotten medieval site of 11 decorated Coptic churches carved in the twelfth century from the volcanic rock at Lalibela in Ethiopia, as a New Jerusalem on African soil. Time had taken its toll, compounded by unskilled attempts at restoration (sadly, a not uncommon problem). Gray identified Italian architects familiar with the site, found significant funding from Lila Acheson Wallace (a *Reader's Digest* founder fascinated by Egypt), and organized a 400-man local workforce paid with non-convertible American funds in the country. He and the architects traveled by mule to the project, which continued from 1966 to 1972, when Emperor Haile Selassie was ousted and political turmoil engulfed the country. (WMF has since returned to help at the site, in partnership with UNESCO.)

The Colonel did not sit long on his mule. From Africa he was next on Easter Island, and thereafter in Kathmandu, Ireland, Spain, and Haiti. But IFM was best known, by far, for its work in Italy.

COL. GRAY IN ACTION

The Venice Committee

Nowhere was Col. Gray's characteristic, immediate action more successful than in Venice. He responded to the disastrous floods of November 1966 by traveling around the United States establishing IFM/Venice Committee chapters, inviting people who loved the city to sponsor a project. Donors in Washington, D.C. sponsored Santa Maria del Giglio; in Minneapolis, it was the Scala del Bovolo; people in Los Angeles adopted San Pietro di Castello; and the architectural historian Edgar J. Kaufman, Jr. financed the cleaning of all the Tintoretto paintings in the Scuola Grande di San Rocco. And so on. Over time IFM sponsored more than 30 projects, and eventually spawned another devoted American organization, Save Venice Inc.

By far the most challenging of IFM's Venetian projects was the Scuola Grande di San Giovanni Evangelista, a huge medieval structure noted for its grand colonnaded entry hall, unique double staircase by Mauro Coducci, and vast upstairs Sala Maggiore under a heavy painted ceiling in the mode of the Ducal Palace. Menaced by an adjacent canal, the entire building needed to be isolated from rising water. A *'vasca'*—a sort of bathtub—was constructed underneath it, and the huge building was further protected from flooding by an automatic pumping system, solutions that set a standard in Venice. When the work was completed, IFM was rewarded with a handsome office on the *piano nobile* that attracted visitors to a public display showing how it had all been done.

It was there, in 1970s Venice, that I first met Jim Gray. As a young American scholar living and lecturing in the city, I volunteered with IFM and came to know him quite well. He was tall and fair, with a military bearing and an energetic, purposeful, no-nonsense manner. Surprisingly (to me, an art historian), he took no particular interest in the artistic qualities of IFM projects. Rather, he saw his role as facilitator between the donor who financed and the superintendency that organized the work. What fascinated him—he was himself an inventor—were the actual processes of restoration. When he wasn't writing his newsletter—descriptions of site visits composed in haste on an electric typewriter and sent out uncorrected—he could be found inspecting a project. Or chatting up a new acquaintance on the Gritti

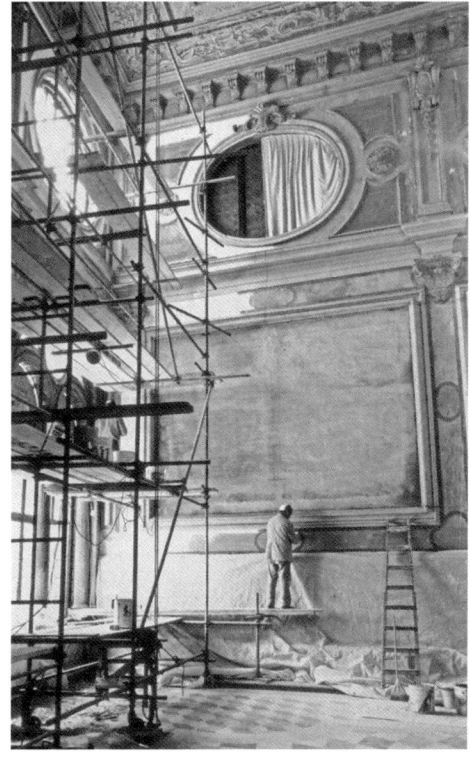

Venice, Italy. The Sala Maggiore (redecorated 1727) of the Scuola Grande di San Giovanni Evangelista under restoration in the 1970s.

Palace terrace (more than one generous donor shared his love of vodka). Or on an airplane (sometimes courtesy the U.S. Air Force) en route to visit another site. He was constantly on the move.

Occasionally he would introduce me to IFM trustees visiting Venice. In particular, I remember meeting Charles M. Grace, the founding chairman, a scion of the W.R. Grace industrial family who was spirited and engaged, though confined to a wheelchair by cerebral palsy. Col. Gray recruited board members from everywhere—there was a wealthy young Bostonian who shared his love of Kathmandu; a suave Englishman with a background in international agencies who had married well; the widow of two (or three?) developers from Washington D.C., and a mysterious diplomatic charmer (described to me) with five passports. The Venetians embraced IFM, its work, and its personalities—Col. Gray created a Venice Committee card that offered its bearer significant local discounts, even at Harry's Bar—and awarded him the Key to the City.

Looking back, the international generosity harnessed for the treasures of Venice in the 1970s—especially by IFM, Save Venice Inc., and Venice in Peril (a British charity), as well as similar groups from other nations—signaled the urgency of a dawning movement. Our collective cultural heritage is endangered. And it matters, deeply, to private individuals everywhere.

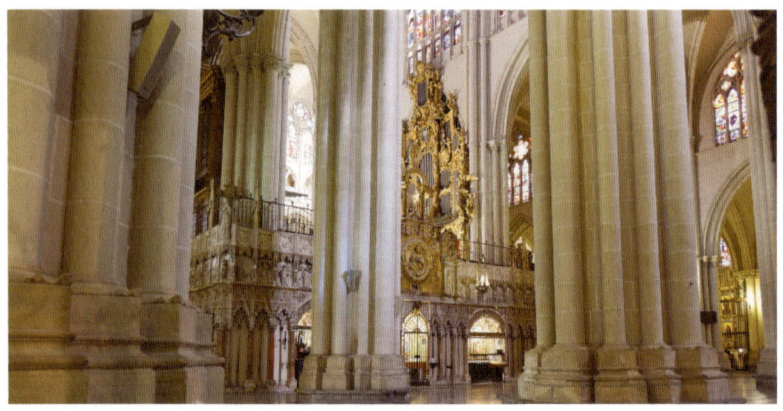

Toledo, Spain. A view of the early seventeenth-century Ochavo Chapel in Toledo Cathedral, restored by IFM and the Kress Foundation in the late 1970s and early 1980s.

THE PIVOTAL EARLY PARTNERSHIP

Samuel H. Kress Foundation

Among the early sponsors of IFM, the Samuel H. Kress Foundation in New York City stands out. Its founder, the dime-store magnate, had been both an avid art collector and an early patron of European monuments restoration in the 1930s. Three decades later, the incomparable Kress Collection bedecked museums across the United States, and the Kress Foundation, led by Dr. Franklin D. Murphy, turned its funding to training art historians and conservators and—in the footsteps of Samuel Kress—to restoring European monuments.

Both Col. Gray and Dr. Murphy—a medical doctor then Chancellor of UCLA (and later CEO of *Times Mirror*)—were decisive men of action, though Murphy was also passionate about history and art (and influential in many arts organizations, especially the National Gallery of Art). Their friendship was cemented in their complementary roles. Kress would select a project and IFM would implement it, ensuring the quality of the work and the financial accountability. These became the enduring guarantees of IFM/WMF. During the 1970s, major long-term restorations in Italy (churches in Venice, Bologna, and Spoleto), several projects at Toledo Cathedral in Spain (after the death of Franco), and a stone conservation laboratory in Venice benefited from the Kress/IFM partnership. Projects in Ireland and Haiti followed.

TRANSITION

The Founder Retires

I joined the Kress Foundation as its incoming executive vice president in 1981. At that time, the two primary beneficiaries of Kress grants were the National Gallery of Art and the International Fund for Monuments, which together received one third of all Kress contributions. (By then, most of IFM's major projects were Kress-sponsored). When Col. Gray's eyesight began to fail, he came to us. IFM had only a skeletal office in Venice, no plan of succession, nor anyone capable of following the site visits and negotiations on which the Colonel thrived. In a word, the future was bleak.

 The situation threatened to leave several long-term Kress projects without adequate management in the near term, and to undermine an entire sector of our funding going forward. The Kress Trustees urged me—by then their President—to join the IFM board to help shape its future, and I thus found myself at the critical 1984 meeting, representing IFM's largest donor.

 In attendance were Jim Gray and a handful of the most active trustees, plus Bonnie Burnham, the executive director of the International Foundation for Art Research (IFAR), recruited to help reorganize IFM because of her background in monuments legislation. Our discussion was clearly divided: we praised IFM's extraordinary record, the founder's vision and tenacity, the lasting accomplishments—and admitted it could not continue as a one-man (unsalaried) operation. Needed was an entirely new organization, with professional staff and clearly defined programs and policies that could provide leadership to the entire demanding, inchoate, chronically underfunded field of architectural conservation. The vision was compelling. But could it be done?

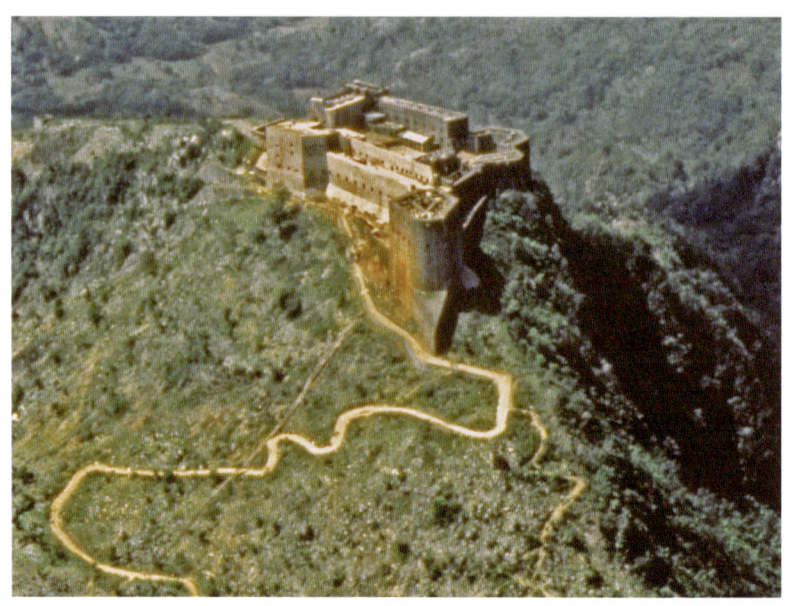

Northern Haiti. Citadelle Henry (1806–20) the largest fortress in the New World, restored by IFM and the Kress Foundation in the early 1980s.

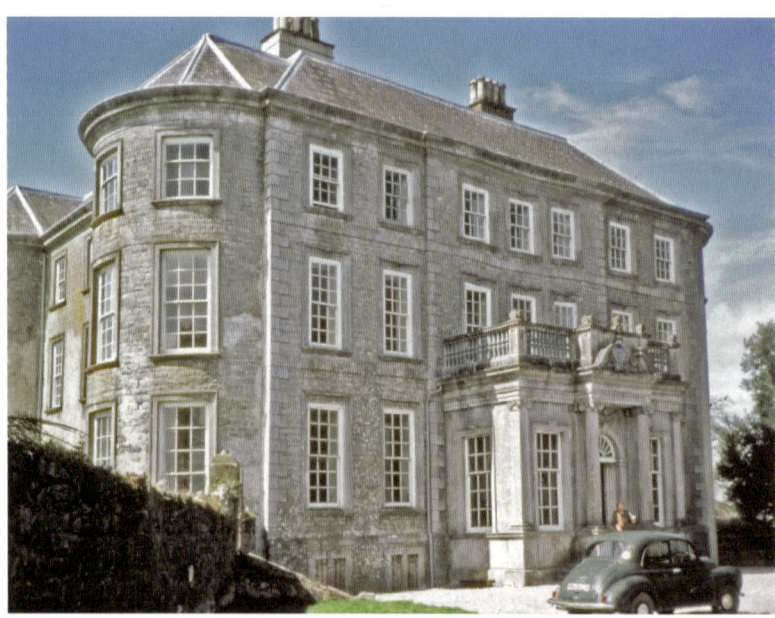

County Cork, Ireland. Doneraile Court, an eighteenth-century Irish mansion in a large wildlife park, an IFM/Kress Foundation project in the early 1980s.

1985–1995

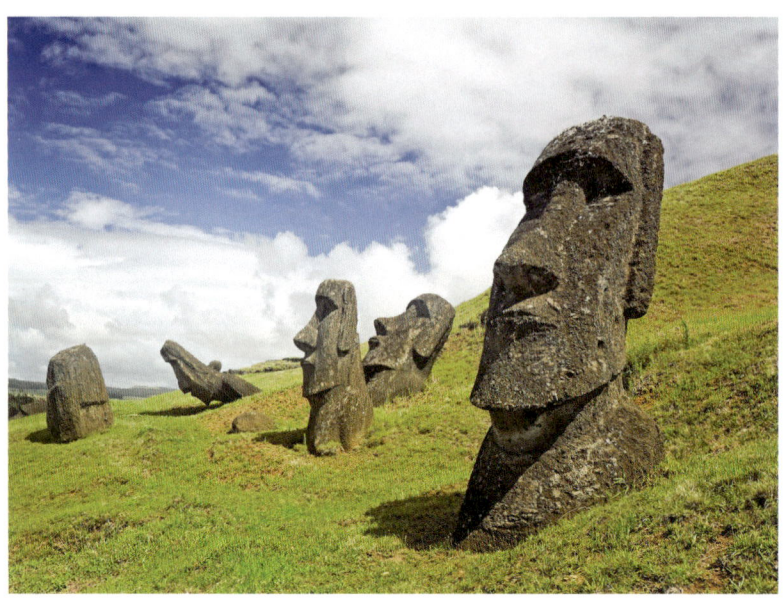

Easter Island (Rapa Nui), Chile. Projects relating to the mysterious moai and other aspects of the island's heritage began in 1967.

Venice, Italy. The church of Santa Maria della Visitazione, also known as the Pietà or Vivaldi's church, was restored in its entirety—from the Tiepolo frescoes to the famous eighteenth-century organ—by IFM and the Kress Foundation in the 1970s.

FINDING OUR WAY
World Monuments Fund

We recognized IFM's limitations, but what were its assets? An outside management survey gave us a breathing spell that confirmed the needs for architectural heritage conservation (enormous), our position in the field (the first and only private-sector international organization), the small existing donor base (already well known to us), and our prospects (very unclear).

The one surprise was a daunting recommendation to change our name. 'International' was political, 'Fund' was misleading (we were not endowed), and 'Monuments' made people think of cemeteries. Moreover, 'IFM' was all too readily confused with 'IMF', which of course was truly international and real money. (This last was the compelling argument). With much discussion and a few misgivings (there were virtually no alternative words, it turned out), International Fund for Monuments (IFM) morphed into World Monuments Fund (WMF). The year was 1985, and the organization was 20 years old.

WORLD MONUMENTS FUND

Taking Stock

Bonnie Burnham, an art historian from Florida with long dark hair—and an experienced non-profit administrator who had worked with international agencies in Paris—was appointed executive director, increasing her time from one day per week to 24/7. Space was found in a Victorian basement on East 72 Street just off Madison Avenue, where the creaky bathtub overflowed with IFM booklets, brochures, and old newsletters. Housekeeping began. Files were organized, budgets reviewed, contractors and donors contacted. There was a sense of energy and purpose, but with deep underlying uncertainties about how WMF would proceed? …be structured? …pay for itself? …attract new donors? …choose new projects? Each of these issues evolved in unexpected ways.

International Fund for Monuments publications.

Damage from the 8.0 earthquake that struck *Mexico City* on September 19, 1985.

THE FIRST NEW PROJECT

Mexican Earthquake Damage

When earthquakes devastated the center of Mexico City in 1985, a concerned philanthropist, Marieluise Hessel, approached WMF to help spearhead a campaign to save the great modernist murals of the city. German-born, with deep interests in art (she later founded the Center for Curatorial Studies at Bard College), she had lived many years in Mexico. With her help we established new contacts in the country that resulted in several joint restoration projects for monuments preservation and, in a new endeavor, training programs in architectural conservation. Working in partnership with local funding sources would become a mainstay of WMF programming, as would helping train young conservators in countries around the world. Emergency response to natural disasters would be another continuing theme.

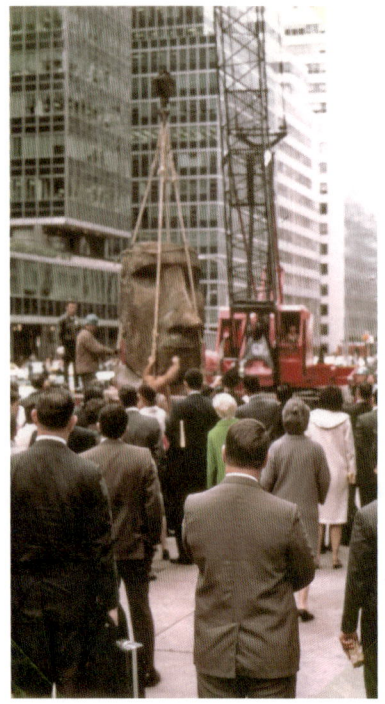 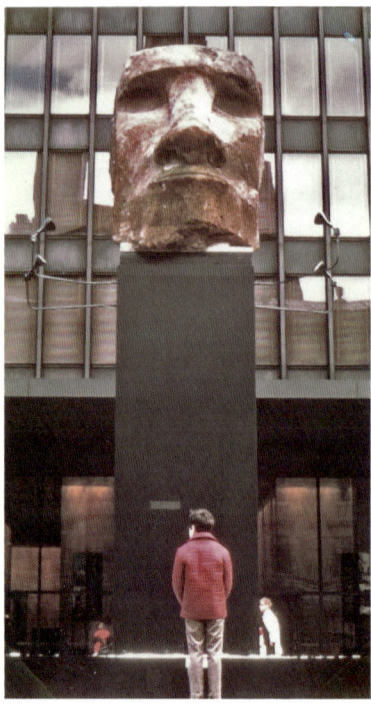

New York City. An Easter Island moai in front of the Seagram building on Park Avenue, 1968.

A BEQUEST FOR EASTER ISLAND

The Moai on Park Avenue

Around this time, WMF received its first legacy, the fruit of one of Col. Gray's more picaresque early adventures. As IFM's work on Easter Island proceeded in 1968, he persuaded the Chilean authorities to loan him a five-ton, eight-foot-high severed head of one of the mysterious stone moai that populate the island and account for its fame. He also persuaded the U.S. Air Force to fly it to Santiago, or, as it happened, all the way to America. Permission was granted to place the piece in front of the newly completed Seagram building on Park Avenue and there, far from the South Pacific, it presided for a month in lonely majesty. Two decades later, a sizable sum for IFM's work on Easter Island was bequeathed to us by a doctor in New Jersey whom none of us had ever met. Such is the power of the imagination.

AN ANCHORING TRUSTEE

H. Peter Stern

Another person moved by the moai on Park Avenue became a key member of IFM's inner circle. H. Peter Stern, a co-founder of the Storm King Art Center in the Hudson Valley, contacted Col. Gray and offered to help. It was a good fit. A German refugee from Romania with a Harvard law degree, Stern's cultural enthusiasms (India and Indian fabrics, historic pipe organs, early music, Brancusi) were boundless. For the board of Col. Gray's nascent organization—and then as a long-serving Vice Chairman of WMF—Stern was an intellectual guide, a generous donor, and a memorable raconteur, in equal measure. He served the organization for almost forty years (1972–2011), and his passion for travel is commemorated in the H. Peter Stern Lecture, established in 2013.

WMF Vice Chairman H. Peter Stern and Executive Director Bonnie Burnham in an undated photograph from the 1980s.

INVENTING A CHALLENGE PROGRAM

Kress Foundation European Preservation Program

On an express train in Italy in October 1986, en route from Milan to Rome after several site visits, the trustees of the Kress Foundation reviewed—and rejected—adopting another soup-to-nuts restoration project. With so many sites in need, shouldn't the Kress Foundation be more dynamic and proactive? Find a way to help more broadly, to encourage more local support? By the time we reached Florence, we were enthusiastically committed to a new vision —an American-style competitive challenge program of small matching grants for European preservation projects, to be administered by WMF.

There were two caveats: Could WMF design and administer such a program? And would the Europeans respond?

One million dollars—the largest commitment IFM/WMF had received to date (and a significant sum in the 1980s)—was granted for the first five years of the Kress Foundation European Preservation Program (KFEPP), starting in 1987. With the funds came new responsibilities: in effect, WMF was itself challenged to define the needs and practices of a nascent field and to develop a framework for grants management—key elements in WMF's growth.

Both the program and the audience had to be defined. Once guidelines and deadlines were established, a handsome brochure was printed and mailed to as many colleagues and agencies in Western Europe as could be identified (former communist countries were added after 1989). Just creating the mailing list was a major step toward defining the preservation field. Caretakers of historic properties received an invitation from a virtually unknown American organization offering competitive matching funds for planning, surveying, and developing projects; for research and discrete elements of fieldwork; and for documentation, publication, training, and professional exchanges. The approach was as novel, at the time, as it was galvanizing.

The response—especially when viewed over the twenty-year life of the program (1987–2008)—was beyond anything we could have imagined, and revealed, compellingly, the scope of the needs. WMF responded with KFEPP grants of up to $25,000 for projects

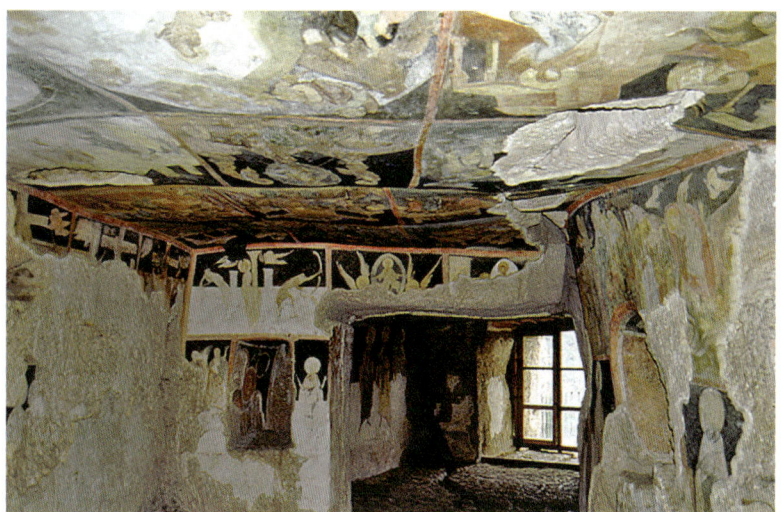

Ivanovo, Bulgaria. Rare and significant frescoes in the rock chapels of a thirteenth-century monastic colony, conserved with a grant from the KFEPP in 1997.

that stretched from archaeological sites to cathedrals, fortifications and gardens, palaces, synagogues and mosques, cemeteries, theatres and civic buildings, even a tearoom in Glasgow—the entire range of European heritage. Grants were made across the continent and the former Soviet Union and a few in the Near East. The matching requirement encouraged governments, municipalities, public bodies, support groups, and private citizens to participate in caring for their architectural treasures, and each grant shone a light on a specific site that made it even more precious. The eventual $10 million in KFEPP grants leveraged many times more in local funding. Original, well-defined, and extremely valuable to the recipients, the program had a profound effect on WMF's evolution—and also on how preservation was practiced and valued.

SPECIALIZED SKILLS

Conservation Training and Preservation Arts in Brooklyn

Specialized skills in traditional building techniques and materials—often lost in the modern world—are a *sine qua non* for historic preservation. Our first education and conservation training programs—today key components of WMF projects around the world—evolved in Brooklyn, including an entire high school devoted to a preservation curriculum.

In the mid-1980s, daunting issues confronted one of New York City's forgotten treasures: 64 stained glass windows of Biblical scenes created by William Jay Bolton for a highly decorated Gothic revival church in Brooklyn Heights. Now known as St. Ann's and the Holy Trinity, the entire complex is an architectural gem by Minard Lafever, completed in 1844, on which no expense was spared. For 100 years it was cherished for the commanding beauty of the building and the glory of the windows, the very first figurative stained glass in the United States.

Serious parish squabbles in the 1950s closed the church to worship, and it suffered a long decline. Eventually, a local school and a performance group gave it new life, but neither they nor the Episcopalian Archdiocese could afford to repair the vulnerable windows.

Enter WMF. So rare and important were the stained glass windows that Bonnie Burnham was able to organize a conservation workshop

Brooklyn, New York. A conservation training student at work on a stained glass window from the church of St. Ann and the Holy Trinity (1844).

Brooklyn, New York. The important Gothic Revival church, St. Ann and the Holy Trinity (1844) contains the earliest figurative stained glass in the United States.

in the church under master craftsmen Mel Greenland and David Fraser that included local high school interns. The project gathered momentum, and the training at the church expanded to masonry, wood, and the beautiful ironwork railings around the building. An exchange with French conservators, sponsored by the Florence Gould Foundation, enriched the program with their expertise.

The career opportunities inherent in the initiative drew education leaders to WMF and attracted the interest of philanthropist Virginia James. In concert with the New Jersey Institute for Technology, WMF developed the first Preservation Arts Curriculum in the nation, implemented in New York City public schools.

Today, WMF sponsors summer internships in craft training at several American sites. Cambodians have been trained to supervise their archaeological sites, Chinese have acquired skills in conserving interior decorations at a laboratory built by WMF in Beijing, Czechs are practicing sustainable site management, Mexicans and Vietnamese using traditional methods on traditional sites. In a recent initiative back home in New York, WMF is partnering with the International Masonry Institute (IMI) on a two-year pilot program in stone masonry conservation at the Woodlawn Cemetery in the Bronx. The goal is to create a model to fill skilled jobs in historic cemeteries across the U.S.

And so on. WMF's reports on conservation conferences and training programs, from Pompeii to Babylon, Ethiopia, Iraq and beyond, set standards and share techniques throughout the preservation movement.

FINDING A PUBLIC FORUM

The Hadrian Award

Our name and our mission announced an international organization. We could chalk up steady professional progress, but we utterly lacked public recognition—for both WMF and the field that we served. Our donors, while very committed, were few. WMF needed more exposure, and a public platform to describe our activities. But could we handle a classic fundraising event?

Circumstances conspired in our favor. In 1988, WMF trustee Paolo Viti, then head of cultural programs for Olivetti, convinced Carlo De Benedetti to be the honoree at a fundraising luncheon for WMF in New York City that would showcase Olivetti's heritage sponsorship within the larger context of worldwide cultural preservation. When the idea was accepted, we focused on the format, and invented the Hadrian Award, an annual award (initially created for us by Cartier, and now by Tiffany) presented to an international leader in the realm of cultural heritage. It is named for the ancient Roman emperor who also cherished the art of the past two millennia ago. WMF would honor the Hadrians of our own age.

Simplicity and clarity dictate the presentation. A short film about WMF and its projects sets the stage. Another illustrates the honoree's activities, followed by his or her own words on why it all matters. Each story is both personal and universal, a resonant message of the role of our human heritage in a notable life. In attendance are members of New York's cultural elite.

With the exception of the 1990 Hadrian Award—presented to the Prince of Wales at the Natural History Museum in London—the event has been held annually in New York City. The roster now covers twenty-seven years and luminaries from near and far, each showing us how direct engagement has protected heritage across the globe. For WMF, an organization operating offstage in strange faraway countries, the Hadrian Award is a vital annual forum at home.

In 2011, WMF created the Watch Award, named for the World Monuments Watch as a way of recognizing individuals whose preservation activities have helped advance the work of WMF. This award is now part of the Hadrian Gala ceremony.

HADRIAN AND WATCH AWARD HONOREES

- **2015** Her Majesty Queen Sofía (Hadrian Award)
 Her Excellency Shaikha Mai bint Mohammed Al Khalifa (Watch Award)
- **2014** Mica Ertegün (Hadrian Award)
 Ellsworth Kelly (Hadrian Award)
- **2013** Roberto Hernández Ramírez (Hadrian Award)
 Andrew B. Cogan and Knoll (Watch Award)
- **2012** Kenneth I. Chenault (Hadrian Award)
 The Duke of Devonshire (Watch Award)
- **2011** Jo Carole and Ronald S. Lauder (Hadrian Award)
 Marcella Pérez de Cuéllar (inaugural Watch Award)
- **2010** Ratan Tata and the Tata Family
- **2009** David Rockefeller, Jr.
- **2008** Houghton, Doreen and Graeme Freeman
- **2007** Rahmi Koç and the Koç Family
- **2006** Gajsingh of Jodhpur
- **2005** The Right Honourable John Julius, The Viscount Norwich
- **2004** Carlos Slim Helú
- **2003** Eugene V. Thaw
- **2002** Hélène and Michel David-Weill
- **2001** The Honorable James D. Wolfensohn
- **2000** Harvey Golub
- **1999** Lord Sainsbury of Preston Candover
 The Honourable Simon Sainsbury
 Sir Timothy Sainsbury
- **1998** Richard Hampton Jenrette
- **1997** Phyllis Lambert
- **1996** His Highness The Aga Khan
- **1995** Lord Rothschild
- **1994** David Rockefeller, Sr.
- **1993** Dominique de Ménil
- **1992** Marella and Giovanni Agnelli
- **1991** Mrs. Vincent Astor
- **1990** His Royal Highness The Prince of Wales
- **1989** Paul Mellon
- **1988** Carlo De Benedetti

Mica Ertegün
2014 Hadrian Award

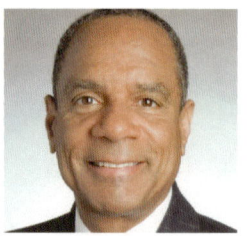
Kenneth I. Chenault
2012 Hadrian Award

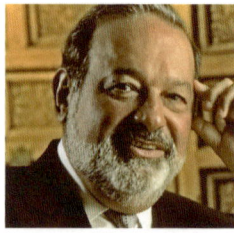
Carlos Slim Helú
2004 Hadrian Award

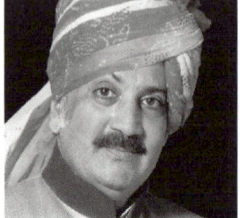
Gajsingh of Jodhpur
2006 Hadrian Award

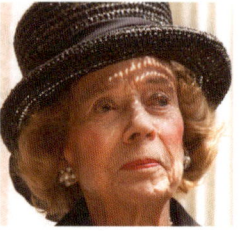
Mrs. Vincent Astor
1991 Hadrian Award

David Rockefeller, Sr.
1994 Hadrian Award

His Highness
The Aga Khan
1996 Hadrian Award

His Royal Highness
The Prince of Wales
1990 Hadrian Award

John Julius,
The Viscount Norwich
2005 Hadrian Award

AN EARLY ALLY

Lord Norwich

Special mention is owed to the noted British author, telecaster, and preservation advocate John Julius, The Viscount Norwich, who received the Hadrian Award for his service to cultural heritage—and to WMF—in 2005. An old friend from the Venice campaign of the 1970s, John Julius was a wonderful ally in our early years in New York, a convincing international voice who spoke for us in lectures and on trips with wit, knowledge, experience, enthusiasm, and a memorable bass baritone. As WMF grew, he accepted our invitations to become the first chairman of WMF Britain, and honorary chairman of WMF.

WHO ELSE CAN HELP?
New Projects and New Donors

My involvement with WMF increased in 1990 when our chairman, Lucius Eastman—a venture capitalist and friend of Jim Gray's who guided the transition from IFM to WMF—stepped down and I replaced him. Our priorities were outreach, outreach, outreach. The Hadrian Award honored international leaders. We needed leaders of our own.

JEWISH HERITAGE

The Hon. Ronald S. Lauder

One of the new trustees recruited during this period was cosmetics heir Ronald Lauder, a former U.S. ambassador to Austria with a deep interest in Jewish life and culture. When he agreed to help us launch a program for the conservation of Jewish heritage, he asked the first and obvious question: What needs saving? Twenty-five years ago, before the "Age of the Internet," creating such a list required a patient scholar who wrote to contacts around the world and collated their responses. It took two years to answer the question.

WMF has since restored Jewish sites in 25 countries. Unexpected examples of Jewish heritage in Croatia, Poland, Morocco, Italy, Belarus, England, Greece, Romania, Ukraine, and beyond have benefited from our program. There is a tiny synagogue in Kochi (Cochin), India, that is the oldest in the country—founded in 1568 by Spanish and Dutch Jews, and filled with the décor of many nations. And there is a grand and beautiful art nouveau temple in Subotica, Serbia, that now anchors a local cross-border project featuring art nouveau buildings in Serbia and Hungary. I also have wonderful memories of a tour of Jewish sites in Morocco. Ronald Lauder was with us, an edgy, intelligent traveler who takes things in with a glance. In 2011, we presented the Hadrian Award to him and his wife Jo Carole, a leader of the Art in Embassies project.

Subotica, Serbia. Subotica Synagogue (1902), an impressive Hungarian art nouveau building. WMF conserved the exterior between 2002 and 2014.

Toro, Spain. The original Gothic polychromy of the western portal (1240) of the Collegiate Church of Santa Maria la Major was recovered during WMF's restoration (before and after views, 1987–96).

REACHING ABROAD

Foreign Affiliates

As our activities in Europe increased through the matching grants of the Kress program, WMF established affiliated groups in Italy, France, Spain, Great Britain, Portugal, and Mexico. We sought out cultural leaders who shared our vision and provided guidance in identifying projects and sources for matching support. Our philanthropic patterns took root differently in each country, based on local traditions and national character, and shepherding the affiliates (they were flying under the WMF banner) required a good deal of attention. Overall, we made good friends for WMF and accomplished wonderful joint projects, such as the Dome of the Invalides in Paris (1994), the painted Gothic façade of Santa Maria la Major in Toro (1995), the Tower of Belem in Lisbon (1998), and St. George's Hall in Liverpool (2008).

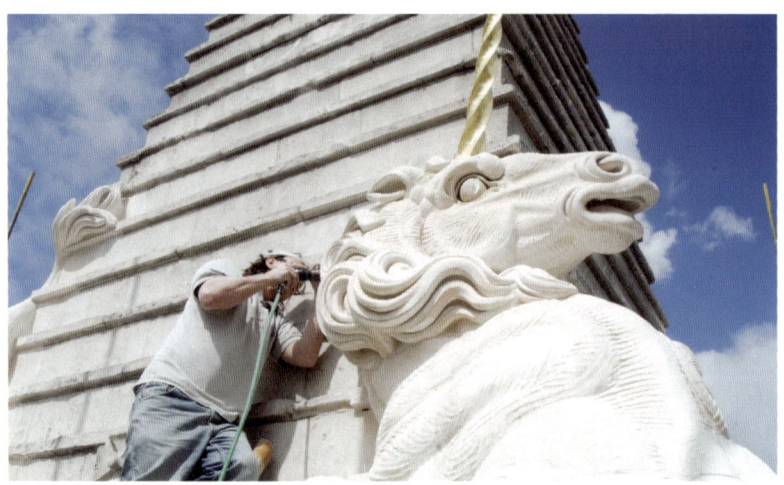

London, England. A unicorn on the spire of St. George's Bloomsbury (1731) by William Hawksmoor. The church and spire were restored with major support from the estate of Paul Mellon, 1997–2006.

A GALLOPING ANGLOPHILE
Paul Mellon

When Paul Mellon (our second Hadrian awardee) published his autobiography, *Reflections in a Silver Spoon* (1992) and included WMF on a list of prospective legatees, I called on him at his Park Avenue townhouse/office—in a room filled with Old Masters—and asked if we might request our legacy now. He graciously granted us $1 million that allowed us to create WMF Britain and open an office in London. Nor did his generosity end there. After his death in 1999, funds from his estate aided several major projects in the U.K., including William Hawksmoor's stunning baroque masterpiece, St. George's Bloomsbury, in London—where our plaque commemorates Paul Mellon's devotion to English heritage as a "galloping Anglophile," a phrase of his own invention.

Many of WMF's educational programs have been supported by Mellon funds, and since 2003, our annual Paul Mellon Lecture has introduced topical preservation issues to the public in New York City. A particularly poignant talk by Anna Somers Cocks, Founder of the *Art Newspaper*, queried "Can Venice Be Saved?" in 2013.

SEEING IS BELIEVING
Site Visits and Inaugurations

To see firsthand opens eyes. To climb a scaffold to a fresco under wraps, follow a conservator along broken columns and ancient walls, discover restored sculpture in a replanted garden—to explore together the intricate, lost, and forgotten achievements of the past is the surest way we have of showing what WMF does and why it matters.

Virtually all of our projects were abroad. We realized that we needed to take people to see them, to explain our work. The planning and logistics were time-consuming, especially in the beginning, but also essential. Our trips have engendered fascination, enthusiasm, understanding, and contributions. And they have enlarged the pool of individuals concerned about heritage around the globe.

Venice, Italy. The late fifteenth-century Scala del Bovolo—an unusual Byzantine-style spiral staircase—restored by Minneapolis patrons of IFM during the 1970s campaign for Venice.

THE FIRST FIELD TRIP

Venice

Our first WMF trip was to Venice. It was sparked, improbably, by a telephone call from the White House. President Ronald Reagan would be attending the Economic Summit in Venice in June, 1987, and would mention our activities and generosity at an event at the Palazzo Grassi. Would Bonnie Burnham attend? This seemed a promising occasion to showcase our impressive range of projects (more than 30) all over the city, and to make new friends for WMF. In the event, Reagan's cameo appearance was virtually lost on our group, which was more captivated by the range and quality of WMF's sites. Serious art lovers, they bonded in their enthusiasm—an effect repeated again and again on WMF trips. This salutary outing gave us new confidence in our mission, new and committed friends, and, many years later, a notable, unexpected bequest.

A MOST BENEFICIAL TRIP

Dordogne

Another memorable early trip took us to the Dordogne region in southern France, an area noted for its painted prehistoric caves (Lascaux is the most famous), medieval ruins, and rugged natural beauty—all of which could be found at our site. Set on a high promontory overlooking a pristine river valley, the Château de Commarque is a rare and long-abandoned fortified castrum from the fifteenth century, with a Carolingian chapel and prehistoric caverns at its base. WMF's work was to stabilize and interpret the massive structural remains.

Our small and jolly group, mostly board members and other friends of WMF, was housed in a converted farmhouse with fare fresh from the garden, served on a long country table. One evening we convinced Chacha Jenkins, a member of the Mexican Jenkins family (one of our co-sponsors in Mexico), to put on her flamenco shoes and dance for us on the table. In the mornings, we would tease Robert Wilson (eventually WMF's most important patron) for ordering an omelet of four egg whites, to the despair of the kindly farm wife who cooked for us. Even the well-traveled Kimmelmanns, Peter (a WMF trustee) and Elbrun, were so charmed by the place that they returned often over the years and their daughter was married there.

Les-Eyzies, France. The Château de Commarque, subject of conservation work in the 1990s.

On our return, Wilson chided me, in his usual sparring way, about our presentation of WMF to the public. Now, having seen our work in the field, his line was revised.

"WMF is a much more important organization than it seems," he said.

"So why not join the board and help us?" I responded. It was perhaps the most important exchange in the history of World Monuments Fund.

A ROYAL WELCOME

Spain

Completing a major project is always an important occasion. This was especially so in this early period, when WMF was still finding its wings. In 1992, as the 500th anniversary of the discovery of the New World drew attention to Spain, we carefully planned a site inauguration at the very place where Columbus received his commission from Queen Isabella—the Royal Monastery of Guadalupe, famed since the Middle Ages for the miraculous statue of the Virgin of Guadalupe. Our complex project centered on a rare, elaborately designed Moorish fountain house, known as the Templete, crumbling at the heart of a large and wildly overgrown cloistered garden. Experts in stucco, tile, and stone, aided by archaeologists, mineralogists, analytical chemists, microbiologists, and garden restorers, had produced another miracle for Guadalupe.

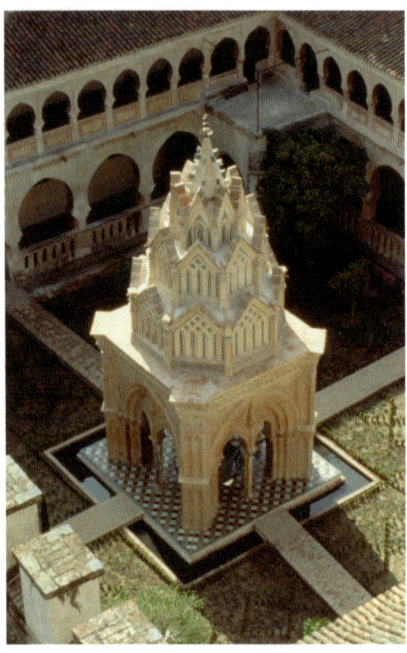

Guadalupe, Spain. The fifteenth-century *mudejar* (**Moorish**) cloister and fountainhouse at the Royal Monastery of Guadalupe, restored 1988–92.

Thence to other WMF sites in Trujillo, Toro, and Toledo. Members of WMF España made our large group very welcome, as on a starlit evening in a fragrant garden overlooking Toledo. King Juan Carlos I and his sister, the Infanta Doña Pilar, Honorary Chairman of our Spanish affiliate, received us royally. As our first major trip, it gave us a successful format that we replicated around projects in France (St. Trophime, Arles), Portugal (sites in Lisbon and Queluz), and England (St. George's Hall in Liverpool).

IN THE KING'S GARDEN

Versailles

A very grand event, worthy of its setting, took place at Versailles on a perfect summer evening in 1996, where we inaugurated—with fireworks provided by Sid and Mercedes Bass—the restoration of the large central fountain in the Potager du Roi, the immense and elaborate kitchen garden of Louis XIV, created between 1678 and 1681. The prime movers of the project were Bunny Mellon (Paul Mellon's wife) and the then-chairman of WMF France, Hubert de Givenchy, who designed a scarf with the garden's ground plan for the occasion. Our goal was achieved when the French authorities saw the value of the project and regenerated the vast structured plantations of fruits and vegetables that nourished the court of the Sun King.

Versailles, France. Louis XIV's private entrance (Grille du Roi) to his 25-acre Potager du Roi (1678–81) at the Chateau de Versailles, restored 1993–96.

MUSIC AND ART

Rome

In 1997, visiting sites in Rome, we were granted the rare privilege of staging a concert by contralto Cecilia Bartoli and pianist Jean-Yves Thibaudet in the great Hall of Hercules in the Palazzo Farnese, in tribute to WMF's work in the Eternal City. We dined in one of Europe's most beautiful rooms, the famous frescoed and stuccoed gallery of the *Loves of the Gods* (1597–1608) by Annibale Carracci.

Still in the future was WMF's participation in restoring the Carracci Gallery (2011–15) as part of a program for conserving historic European interiors. The rejuvenation of the ancient gods was cause for another celebration, and in June 2015, we revisited our projects in Rome during our 50th Anniversary. Our final, unforgettable evening at the Farnese Palace featured a stroll under the sparkling amorous gods and a concert on original instruments by William Christie and Les Arts Florissants, sponsored by WMF Trustee Sydney Houghton Weinberg, again melding baroque images and sound in perfect harmony.

Essential demonstrations of what we do and why it matters, WMF's trips are a staple of our annual roster. The destinations vary but the theme is constant—to introduce our fieldwork, and the people who conduct it. It may be a specific site (Angkor, Assisi after the earthquake), a region (the Yucatan, St. Petersburg), or a country (Peru, China, Turkey, Cuba, Tunisia). The trips are our best offering—the chance to experience, in the place, the degree to which WMF's work makes a difference, how restoration renews a community, how sharing it engenders mutual pride. Today, our trips are guided by WMF's President's Council, a donor group enthusiastically led by Brook Berlind (a trustee) and Joan Hardy Clark—both of whom discovered World Monuments Fund by traveling with us.

AS THE WORLD TURNS
New Preservation Issues

The international political ferment of the late 1980s reverberated at WMF, whose small but growing staff was now located on the upper floors of the Kress Foundation building on East 80th Street.

As the communist stranglehold on Eastern Europe loosened, the neglected heritage of the region came into focus—remarkable buildings and sites long hidden from western eyes, deteriorating from lack of attention or worse. How to protect such historical treasures within the whirlwind of social and economic change?

And as diplomats in Paris struggled to create political stability in Cambodia, WMF was invited to send a team to review the state of the monumental ruins of the mysterious Khmer Empire at Angkor, unvisited during 20 years of warfare. We have been working there ever since.

EX-COMMUNIST EUROPE

Czechoslovakia

As the communist world imploded, WMF and the Kress Foundation focused on Central Europe, convening a session at the Salzburg Seminar in 1990 on the relevance of historic preservation—still a nascent movement—to the many other urgent needs in the ex-communist countries. The following year, at Prague Castle, WMF sponsored the European Monuments Forum on the same issues, with the Prince of Wales in attendance. Prague itself was a prime example. Untouched by war and devoid of such modern intrusions as neon lights, the great cultural capital was at once grand and shabby, its splendid buildings patched and forlorn and now suddenly on the cusp of momentous changes involving property restitution and private enterprise, tourism, and economic development, for starters.

Our goal—in Prague and at a specialists' sequel the following year—was to help, in the first instance, with defining what needed to be done. We worked with government officials and colleagues on the enormous challenges of evaluating and protecting their heritage. Their eagerness as custodians was as touching as their inexperience; we discovered, for example, that double-entry bookkeeping did not exist in the

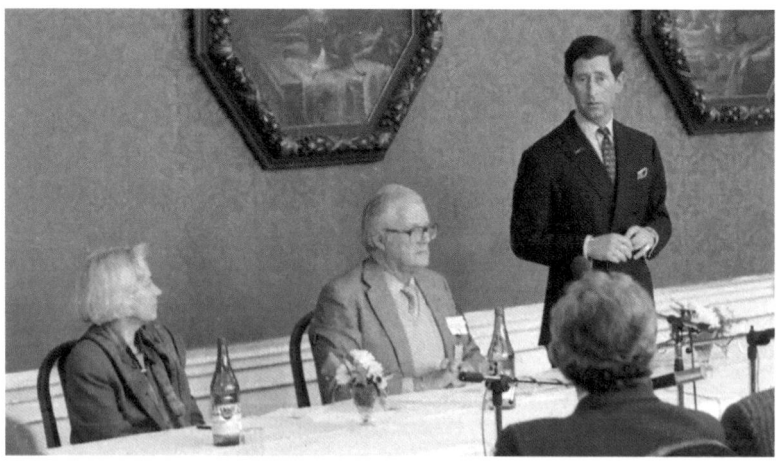

Prague, Czechoslovakia. Preservation issues in post-communist Europe were the topic of a forum at Prague Castle, 1990, sponsored by the Kress Foundation and WMF. Dr. Marilyn Perry, Viscount Norwich, and The Prince of Wales.

Planning charettes of international experts and local stakeholders helped protect the cultural landscape of *Lednice and Valtice, Czechoslovakia* (later Czech Republic), 1993–94.

communist world. As best they could, they had defended the historic context of their past; now they hoped to restore it for the future. We offered small matching grants from KFEPP, and struggled to refine our message for their circumstances. Cultural heritage, like mineral reserves, oil, or the environment, was a depletable resource requiring policy guidelines for its protection. We were learning as much as they were about the complexities of heritage conservation.

Over time, these initiatives bore fruit. In the Czech Republic (as it became), the Kress Foundation sponsored an exploratory tour by Lubomir Chmelar, a native Czech with international preservation experience who had never lived in his country. He made valuable contacts for WMF and, with his late wife Tiree, was an important part of WMF's work in protecting the largest cultural landscape in the region, the 700-year-old estate of the Liechtenstein family between Lednice and Valtice on the Austrian border. WMF's charettes—intensive planning sessions with many stakeholders—opened local eyes to how shared architectural and landscape conservation could benefit local economic development. Today a 250-mile Prague-Vienna greenway invites you to bike or hike through storied hamlets and landscapes connecting the two most fabled capitals of Central Europe, where menacing border guards so recently stood.

AFTER THE KHMER ROUGE

Angkor

Still relatively unknown in the West in the early 1990s when WMF sent its first exploratory mission, Angkor was an impressive but daunting site by any standard. Built between the ninth and the fifteenth centuries by successive Khmer kings, each creating new structures to celebrate his exploits, the Ankgor Archaeological Park extends over more than 400 square kilometers (250 square miles), incorporating a sophisticated system of reservoirs and waterways connecting a still unknown number of Buddhist and Hindu temples. As best they could, our experts, led by British preservation architect John Sanday and French Khmer scholar Claude Jacques, reviewed the core area around Angkor Wat, the most famous temple complex. They found that the site had not been a military target (as had been feared), the jungle had encroached as predicted, and the greatest damage by far was from looting. This report launched WMF's long association with Angkor, a flagship sailing still.

Travel to Angkor at that time was an intrepid affair. Our first tour to Cambodia was a small and eager group willing to rough it. The hour-long flight from Phnom Penh was a lone and rickety Russian plane with broken seats (the only one in service) that filled with a fog as it took off. On-site transport was a rundown school bus on rutted roads with military patrols, and accommodation at the barely reopened small, old Grand Hotel included water and electricity in occasional spurts. Exploring the immense and majestic deserted ruins was all-consuming, and one exhilarating night we clambered around the Bayon—a strange imposing pavilion with huge carved heads—in the light of the full moon. Here, in the vast splendor of a long-lost civilization, were extraordinary new challenges for WMF.

We were the first American group to work at Angkor, where other nations, especially the French (the former colonial power), also adopted a number of projects. But there were significant differences. Our initial site, the large monastic complex of Preah Khan (or 'Sacred Sword', dedicated in 1191), was impressive not only for its scale (one third the size of Central Park within its enclosing walls) but also as a place of religious tolerance and learning. Our goal was to stabilize it as a

partial ruin, clearing the jungle and resetting the toppling stonework in dangerous areas to permit visits. So overgrown was the site that we uncovered an entirely unknown *two-story* stone Khmer building, a presumed library, within the compound. Experts in subjects from stone conservation to forestry and insect control were called upon for the project.

During our annual trips to Angkor—a popular offering often led by John Stubbs, WMF's first Director of Field Programs—we staged a very special event in the Hall of the Dancers at Preah Khan, a roofless space so named for its beautiful carved friezes (pictured on the cover). On the

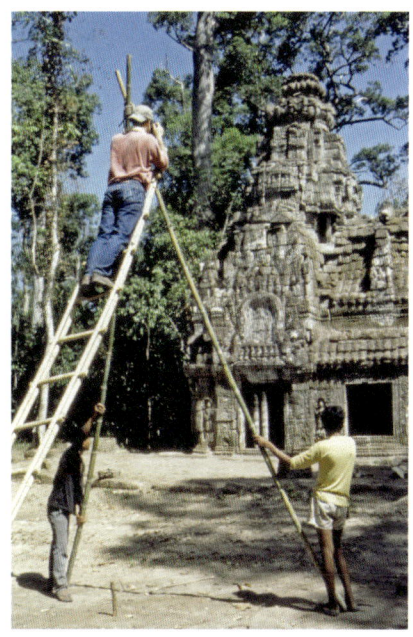

Siam Reap, Cambodia. John Stubbs and assistants photographing at the twelfth-century temple complex of Preah Khan at Angkor Archaeological Park.

uneven stone pavement, in slow and complicated poses, graceful barefoot young Cambodians in traditional costumes revived their ancient dances. One was so talented that Anne Bass arranged for him to be schooled by the New York City Ballet.

Significantly, we were the only international group to provide management training to our local workforce, so that the survivors of their country's brutal massacres would be able to take responsibility for their heritage. WMF sponsored the first information center at Angkor, designed by a young Cambodian architect who had studied in Russia. In 1999, WMF stewarded the creation of the Center for Khmer Studies (CKS) in Siem Reap, a new library and research facility for a country where all education—and all knowledge of history—had been obliterated. Today an important independent institution, CKS has been shaped by the leadership and dedication of WMF Trustee Dr. Lois de Menil, an expert in international relations.

Looking back over WMF's long association with Angkor, now uninterrupted for 25 years and six major projects (each embracing new challenges), the vision is of the majesty of the place, the steadfastness of our workforce, and the enthusiasm of our visitors. This last brings to mind the inimitable Millers, Sam and Rosetta. He was a WMF trustee and the droll director of the Newark Museum, she a free-spirited, deep-voiced cabaret singer from South Carolina given to outlandish costumes. Angkor captured them at first visit and they became its best promoters, urging their friends to travel with them and sponsoring Cambodian fêtes in New York. No one on their trips will ever forget. They are no longer with us, but their enthusiasm buoys us still.

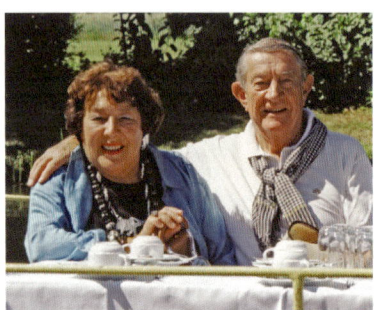
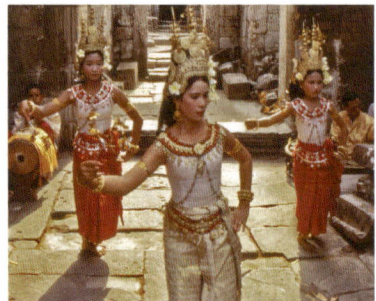
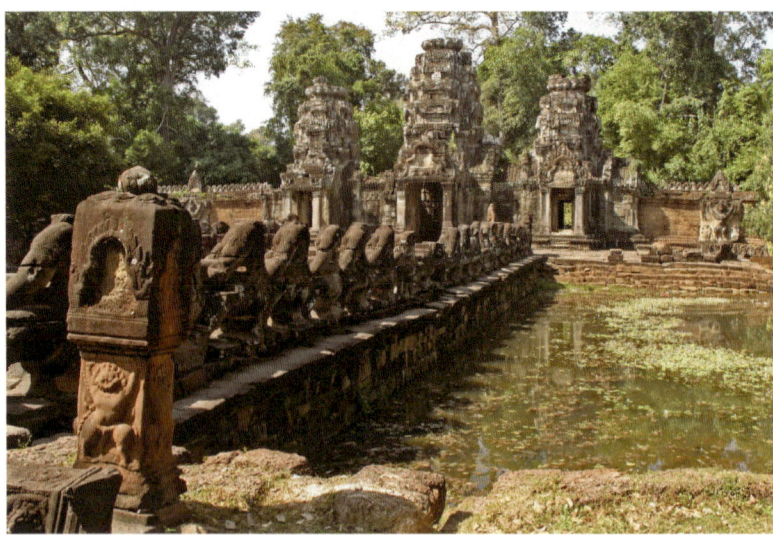

Images from Cambodian visits: Rosetta and Sam Miller; Dancing in the Hall of the Dancers at Preah Khan; Semi-divine figures line the causeway at the eastern entrance to Preah Khan.

1995–2015

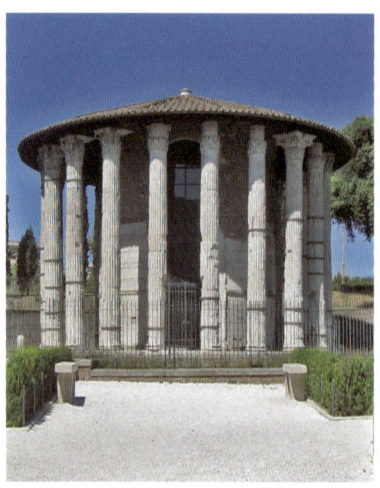

Rome, Italy. A rare Greek building in Rome, the Temple of Hercules (second century B.C.) was included on the first World Monuments Watch and received American Express support for its restoration, 1996–2003.

Chengde, China. WMF Executive Vice President Henry Tzu Ng (left) presents American Express funding to conserve two monumental sixteenth-century wooden statues in Puning Temple, 2008.

San Rafael District, Peru. A fortified temple at least 2,300 years old, Chankillo was recently recognized as a solar observatory. It was listed on the 2010 World Monuments Watch, and has received financial help from WMF.

A WORLDWIDE REPORT CARD
World Monuments Watch

1995 was a banner year for WMF. We celebrated the organization's 30th anniversary with a publication— World Monuments Fund: The First Thirty Years— *that described the outstanding projects of the previous three decades. We had now completed ten years under Bonnie Burnham's leadership (she would soon be promoted to President), and we moved to new offices on two floors in a tiny building on Park Avenue and 81st Street. That year we also created a newsletter,* Milestones, *which shared our activities with our supporters twice a year. But far and away the greatest excitement was the launch of an ambitious new program that would dramatically change the organization and its international role— the World Monuments Watch.*

In its origins, it was a simple idea. Just as environmental agencies created lists of endangered species, WMF would organize a biennial worldwide list of the *100 Most Endangered Sites*. The American Express Company endorsed the concept and agreed to sponsor the project for the first five years, for $5 million. (Amex was WMF's first corporate donor, and this was our largest overall grant to date.) A jury of international preservation experts would convene in New York every two years to select the 100 sites for the list. Amex executives would choose projects to receive Amex grants, based on responses from their field offices and overall corporate objectives. (We sometimes presented huge fake American Express checks at local press conferences.) A listed site might also qualify for grants from the KFEPP, the Jewish Heritage Program, and other donors (sans the fake checks).

Organizing the outreach (this was well before the universality of the Internet) was the primary issue. WMF needed to define the program, establish the guidelines (heritage at risk from the forces of nature and the impact of social, political, and economic change), and contact as many custodians of buildings and sites around the world as we could (1,700 the first year), in languages they could read. It was easy to anticipate problems—would overworked administrators and restorers take the time to apply? Would they be reluctant to admit to projects in need? Would they realize not all would receive grants? Would they get their packets in on time? Would we receive at least 100 worthy applications?

And, of course, what would be nominated? It was a very heady time.

To our relief and gratification, 253 submissions (from 70 countries) arrived—mostly in last-minute postal trucks—for the first Watch. The jury met for three days and their discussions helped set the course for the future of the program. At last, 100 sites were selected, from 53 countries. Large posters were printed illustrating all 100 sites—a rich and astonishing display of mankind's cultural creations, ranging from Hagia Sophia in Istanbul and the Temple of Hercules in Rome to a sugar mill in Barbados, a fountain house in Cairo, a synagogue in Fez, war torn villages in Bosnia, a church in Quito, and a conservatory in San Francisco, all in need. The 1996 list of *100 Most Endangered Sites* was as enlightening as it was sobering.

The Watch quickly became WMF's signature program, and the memories associated with it are legion. In some instances, it literally

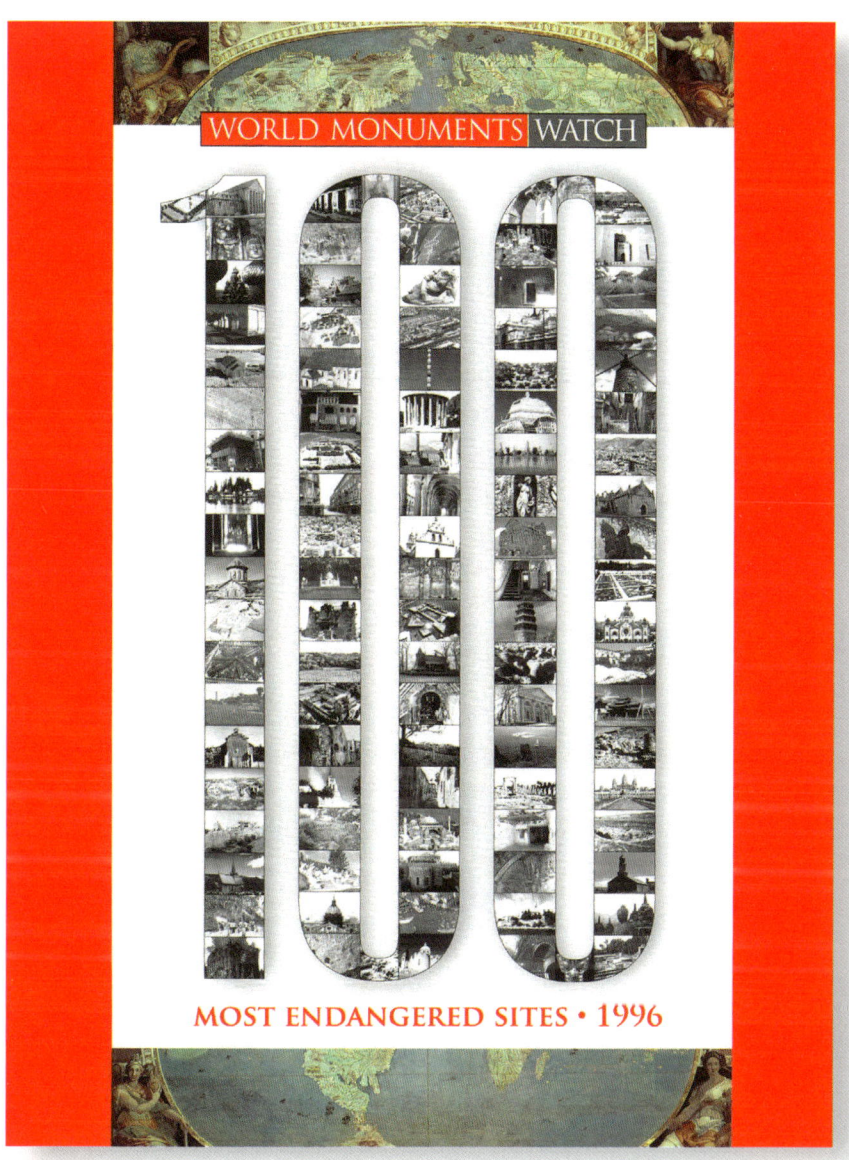

World Monuments Watch: 100 Most Endangered Sites—1996.
The cover of the first announcement booklet was also a large poster.

changed the lives of the nominators, as their sites received new attention, and their significance was understood.

For me, one of the most poignant and moving events associated with the Watch was our announcement of the second list of *100 Most Endangered Sites* in 1998. This is a popular press event, that year held as a breakfast at Windows on the World, the restaurant atop the North Tower of the World Trade Center. That alone makes it memorable, but there is more.

Our featured speaker was the chief of the White Mountain Apache Nation in Arizona, whose nomination of Fort Apache made the Watch. "These tall buildings in New York," he said, "remind me of the tall trees in my homeland, which are older than these buildings, as my people and their ways are older than the people here." He went on to explain that they had nominated Fort Apache—an infamous symbol of the oppression of the Apaches—"because it is important to remember even the most terrible times, if we are to grow beyond them." For them, inclusion on the Watch—not for the quality of the buildings but for the overwhelming historic importance of the site—mattered for the

Apache Tribal Lands, United States. Ruins of Enlisted Men's Barracks at Fort Apache, Arizona (1871) when it was listed on the 1998 World Monuments Watch.

recognition as well as the funding it helped them secure.

It is not too much to say that the World Monuments Watch elevated historic preservation into a worldwide movement. The statistics are impressive—since 1996, 740 sites in 133 countries have been listed, of which 40 percent have received grants through WMF totaling more than $90 million. But this is only the beginning. Selection to the Watch opens local eyes, and pockets. We calculate that another $200 million in funding (at least) has been leveraged for projects by virtue of Watch listing. And sometimes the spotlight of public opinion suffices to ward off a looming disaster, such as ill-designed public works projects endangering a medieval graveyard in Ireland, and a traditional coastal town in Japan.

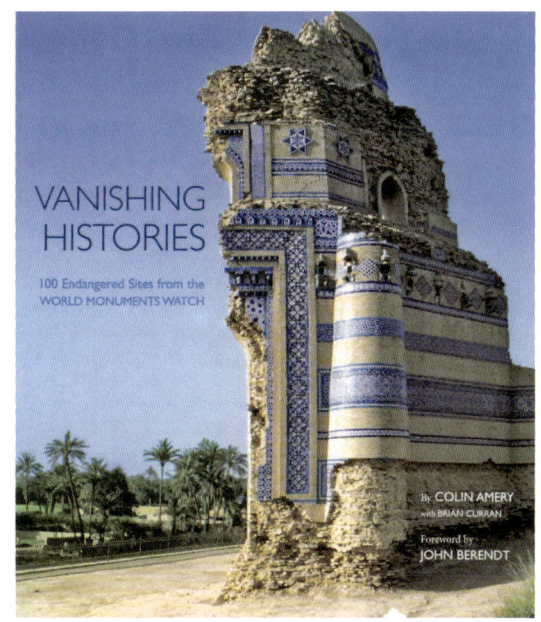

Every single Watch site is precious and has a story to tell that may soon be lost. The urgency is tangible in *Vanishing Histories: 100 Endangered Sites from the World Monuments Watch* (Abrams), a handsome hardcover book with vivid images by Colin Amery and Brian Curran (the then-director of WMF Britain and an associate) published in 2001. The excitement of the discoveries unearthed by the Watch—such as the partially ruined Indus Valley mausoleum on the cover of the book —is sobered by the range of threats that they face.

One brightening response is the recently created World Monuments Watch Day. To celebrate their heritage, WMF encourages local sponsors to host concerts, tours, seminars, lectures, cleanup days, traditional dances, etc., at their Watch sites. They send very jolly images back for the WMF website.

Robert W. Wilson on a World Monuments Fund trip to the Dordogne, France, 1989.

UPPING THE ANTE
The Robert W. Wilson Challenge to Conserve Our Heritage

American traditions of philanthropy have literally changed the world. We were privileged to see this in action as the generosity and vision of a single donor attracted more than twice as much in foreign contributions to more than two hundred heritage sites in fifty countries abroad—and moved WMF to the center stage of international heritage conservation.

Few private individuals have had as great an effect through their own philanthropy as Robert W. Wilson (1926–2013), a legendary self-made short-seller who retired from high-powered investing with a huge fortune and devoted the rest of his life to strengthening organizations in the arts, education, and—primarily—conservation. He was not an easy person, famously fond of hard ideas and bad jokes, readily displeased with restaurant wines and liberal stances, but above all a passionate lover of beauty: rare birds, ancient ruins, Grand Opera. We found him by chance, a friend of a friend at an early WMF party who aggressively challenged us as to why Americans should contribute to restoring cultural heritage abroad?

Soon enough, he understood, and in due course instead of needling us he turned his challenge outward. In the new World Monuments Watch, with its enormous array of worthy projects from all over hoping for financial help, Wilson saw a splendid opportunity to leverage his own funds, draw new international money to the field, and enlarge the reach of World Monuments Fund—all at one stroke. In 1997, he established the Robert W. Wilson Challenge to Conserve Our Heritage. On a site-by-site basis, each approved by him (his concern was protecting beautiful places), the Wilson Challenge offered matching grants for foreign contributions to WMF projects on two levels: a 1:1 match for private-sector donors, and a 1:2 match for public support.

Although his initial goal was to raise more private philanthropy abroad—hence the one-to-one match for private contributions—he could be flexible in the right circumstances. An early project—restoring the majestic Belvedere Gardens in Vienna—had reached the limit for Wilson funding. The Austrian government asked to be reconsidered, Wilson's match was raised to 1:3, and the project moved ahead. He made financial leveraging, like project partnerships, fundamental to WMF's work.

A sense of urgency drove him. "Too many beautiful places are being lost" was his mantra, and he pushed WMF to identify more worthy projects and matching donors. We had to work hard to keep up with him, and everything about the organization—from our growing professional staff to our record-keeping, our field programs, our public relations, our training programs, and our outreach—benefited. His opinions and repartee enlivened our board meetings. So very much

Rome, Italy. The garden of the thirteenth-century cloister of Santi Quattro Coronati, restored with matching funds from the Wilson Challenge 2002–05.

was happening! The same was true of the sites he funded as restorations revitalized communities with new pride in their heritage.

Traveling with Wilson, especially in groups, was always an adventure, since keeping him interested was a priority, and you never knew what would (or not) catch his fancy. For him, a site visit was typically a quick scan of the setting, perhaps a question or two, or a complaint ("the guide talks too much"), and a retreat—such as finding a corner to read his newspaper in the gilded baroque library in Coimbra, Portugal. Even at receptions in his honor he could be abrupt. After an *a capella* concert in tribute to his generosity by the nuns of the medieval church of Santi Quattro Coronati in Rome, he refused a drink and wandered back to the bus. ("All I did was write a check.") If a site surprised him—as the quality and scale of St. George's Hall in Liverpool, a mid-nineteenth-century civic building in the classical style with law courts, a concert hall, and a huge central public space—he let us know ("so much better than your description").

My favorite memories of him are from a side trip to Kyoto in 2007, accompanied by Henry Tzu Ng, WMF's Executive Vice President, and a young American conservator, fluent in Japanese. We were there to visit a recent and very surprising discovery—several rare and virtually forgotten Imperial Buddhist Convents, still tended by a few

loyal nuns and abbesses who could ill afford even essential maintenance. Traditional residences for unmarried high-born court women, the medieval convents survived unnoticed in the shadow of the much larger monasteries, their rich collections of imperial furnishings and art largely intact. The history of the project fascinated Wilson, who slowed his pace to that of the nuns. He introduced himself—"I'm the moneybags"—with his inimitable sardonic laugh.

Cairo, Egypt. The Blue Mosque (Jama'a Al-Aqsunqur), 1347. One of several monuments in Cairo restored in collaboration between the Wilson Challenge and the Aga Khan Trust for Culture, 2009–15.

"Moneybags" with a clear vision and a sharp wit. He remained a lively protagonist in the Wilson Challenge until his death in 2013, by which time WMF had granted $100 million of his money to 201 cultural heritage projects in 51 countries—many of which he visited—and had directly leveraged the equivalent of over $200 million for these projects from non-American sources. (Additional funds attracted for ancillary activities would make the sum far higher.) Sites from Albania and Argentina to Venezuela and Vietnam—representing virtually the entire spectrum of artistic cultural heritage—are today in better shape and better cared for, more cherished and beloved, because of the focused generosity of the churlish son of an insurance executive from Detroit.

It is important to add that in one essential way, WMF (and philanthropists in general) disappointed Robert Wilson. He was intensely gratified by what his funding had leveraged in conserving beautiful sites throughout the world, and he anticipated that we would find others who, seeing the impact of his matching funds, would be inspired to follow suit and succeed or even outdo him. We can only hope that this instinct—like all of his successful investing—is simply ahead of the market curve.

A COMMITTED PARTNER
Aga Kahn Trust for Culture

Around the world, private individuals, preservation groups, and government agencies responded to the Wilson Challenge and contributed matching funds for the preservation of their local sites. The most generous non-profit matching partner, the Aga Khan Trust for Culture, provided both funding and expertise for projects in Europe, Africa, India, and the Near East.

An early and continuing partner for the Wilson Challenge—and a leader in demonstrating the social importance of preserving historic architecture—is the Aga Khan Trust for Culture (AKTC), with whom WMF has undertaken several exemplary projects. The first, launched in war-damaged Mostar, Bosnia, in 1997, sponsored the reconstruction of the famous Ottoman Old Bridge (Stari Most) of 1566 and its surrounding neighborhoods, symbolizing the start of postwar healing. Similarly, several rehabilitations of once-beautiful, finely wrought structures in the heart of Cairo's largest slum, the medieval Darb el-Ahmar, have shown how basic, practical preservation—the removal of trash and rubble, stabilizing and cleaning structures, adapting them to new uses—vitalizes urban renewal.

Collaborating again in Delhi, WMF and AKTC partnered with the Archaeological Survey of India and the Municipal Corporation at one of the most visited sites in the city, the impressive complex of medieval Mughal buildings popularly known as Humayun's Tomb. Our work combined needed repairs with historical research, leading to a new appreciation of the entire area and, ultimately, the removal of a city road that divided the site in two. One of the memorable events of a WMF visit in 2006 was following Prince Amyn Aga Khan, a dapper and worldly Paris-based WMF trustee, as he paced out the future gardens and waterways on the barren earth. His vision is now realized as part of a WMF Delhi Heritage Route that connects and explains key sites in the city, sponsored by American Express.

Seeing India with Prince Amyn—he would glance at a palace ceiling and point out a portrait of his great-grandfather—gave a special dimension to our trip. It also confirmed the attention that he and his brother, the Aga Khan, pay to our joint projects. And the heartbreaking losses we share: after a decade of major discoveries at the Citadel in Aleppo, Syria, our work was suspended in 2011 with the outbreak of civil war. What will be left when the guns and grenades are at last silenced?

IN THE WORLD'S EYE
New Approaches, Famous Places

The World Monuments Watch and the Wilson Challenge offered recognition and financial support for hundreds of sites in dozens of countries every year. In addition, WMF was also a resource for technical support through the expertise of our professional staff and our international contacts in activities such as analyzing conservation needs, planning interventions, or creating on-site training programs.

Some of the world's most famous places—the Valley of the Kings in Egypt, the Taj Mahal in India, and Hagia Sophia in Istanbul—appeared in our annual reports, along with lesser-known sites like medieval churches in Poland, a sixteenth-century monastery in Bhutan, and the Dampier Rock Art Complex in Australia (probably the oldest in the world). As WMF's capabilities expanded, and our work became better known, we accepted larger and more complex projects—always in partnership with strong local commitment and support. Some of our best-known projects have also established new norms and procedures for the entire preservation movement.

THE ANCIENT WORLD

Pompeii

The lure of Pompeii—the most famous archaeological site in the world—draws two million visitors a year to the Bay of Naples. A thriving ancient Roman city of 20,000, interred by a volcanic cloud from Mount Vesuvius in the summer of A.D. 79, was erased from memory for 1,500 years. Rediscovered by chance in the eighteenth century, the site ignited a universal craze and invented modern archaeology. Now an open-air museum covering 120 acres with 1,500 excavated buildings, it beckons to the universal fantasy of stepping into the distant past. Ten thousand people a day try to do just that.

Like many overburdened archaeological sites, Pompeii suffered from deterioration and a lack of overall planning when it was listed on the first World Monuments Watch in 1996 (only 16 houses could be visited, as compared to 64 in 1956). Here was an opportunity to help establish protocols for conserving archaeological sites. With support from the Kress Foundation, WMF and the Italian authorities collaborated on a conservation management strategy, a pilot conservation project, conservation planning for an entire city block, the restoration of a famous house, and the first international conference on preserving all of the ancient sites in the shadow of Vesuvius. As a result of the Watch listing, the Italian government resolved to permit the site to retain its tourist revenues, to ensure its protection and improved display.

Pompeii, Italy. WMF spearheaded a conservation survey and related projects at ancient Pompeii (buried in A.D 79) with Kress Foundation sponsorship, 1996–2002.

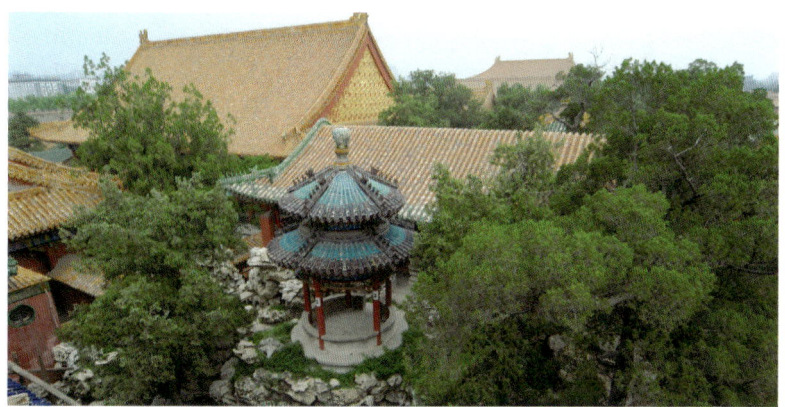

Beijing, China. Restoration at the Qianlong Garden began in 2002 in partnership with the Imperial Museum and support from the Freeman Foundation and other donors.

ASTONISHING DISCOVERIES

The Qianlong Garden Complex in the Forbidden City

Another closed and lost world—of a very different nature—has taken WMF into the fabled heart of the Qing dynasty emperors of China, arguably the wealthiest country on earth in the eighteenth century. In 1771–76, the long-reigning (1735–96) scholar-connoisseur-warrior Qianlong Emperor designed and built an extravagant retreat for his prospective retirement (20 years hence!) in a far corner of the Forbidden City. The haven—27 buildings in four linked gardens—awaited him in quiet splendor, and in vain.

The compound disappeared from memory, abandoned in the midst of the pomp of the Imperial Court, itself a world closed to the outside for 500 years (1421–1924). So forgotten was the Qianlong Garden that when Bonnie Burnham requested a visit on her first official trip to China, even some Forbidden City senior staff had never seen it.

They discovered a time capsule of imperial magnificence. Covered with 200 years of dust were rooms designed as the acme of eighteenth-century Chinese decoration and craftsmanship, with bamboo marquetry, white jade cartouches, precious woods with rare finishes, silk paintings, elaborate screens and panels, double-sided embroidered silks, wall paintings (including a Western-style *trompe-l'oeil* ceiling),

Beijing, China. Design survey of the Qianlong Garden Complex (1771–76).

wallpapers, and exquisite furniture. All for the emperor's private enjoyment. The so-called Lodge of Retirement—*Juanqinzhai*, or the Studio of Exhaustion from Diligent Service—was the first building to be restored in a partnership between WMF and the Palace Museum for the entire complex that began in 2002.

Shared expertise is the heart of the project. WMF constructed a state-of-the-art conservation facility in Beijing, and Chinese conservators visited the U.S. to meet colleagues and share techniques. Aged craftsmen, still following traditional methods, were found in provincial China and their skills revived. Scholars of Chinese art studied the exquisite discoveries, and a partnership with the Peabody Essex Museum created an exhibition of the Qianlong Emperor's treasures that toured to several American museums, including the Metropolitan Museum of Art, sharing a stunning display of the Emperor's taste and the epitome of the artistry that he cherished.

This is also a case of a perfect conjunction of donor and project. The Freeman Foundation, a major sponsor, was established to foster ties of understanding between Asia and the West. What better than sharing the excitement of the Qianlong discoveries? And the Imperial Buddhist Convents in Kyoto? In 2008, WMF honored the late Houghton Freeman, his wife Doreen, and their son Graeme with our Hadrian Award.

Beijing, China. Juanqinzhai, or the Studio of Exhaustion from Diligent Service, the first pavilion in the Qianlong Garden Complex to be restored (2002).

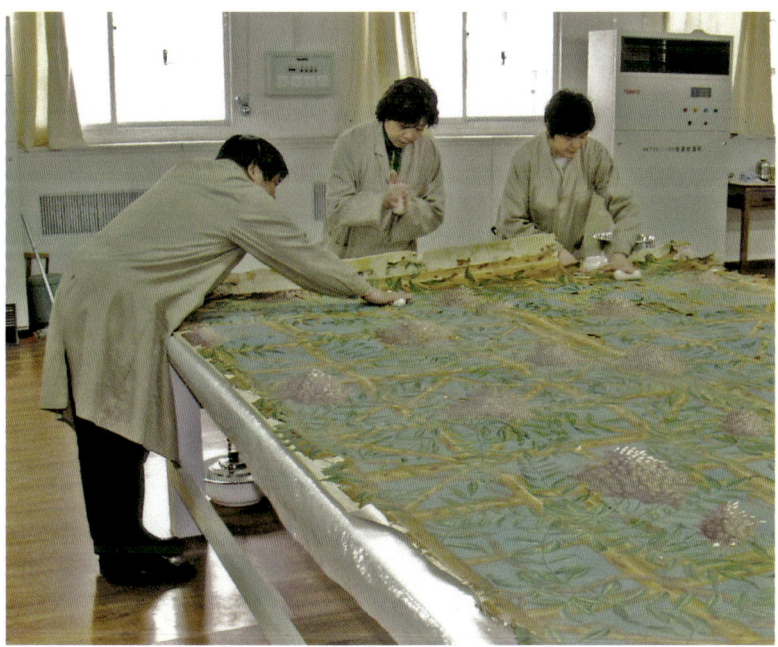

Beijing, China. Conservation training as part of the overall Qianlong Garden Complex project.

RECOVERING THE ALMOST-LOST

Stowe House

On a very different scale of private eighteenth-century splendor—grandeur built to be admired—Stowe House, in Buckinghamshire, United Kingdom, is perhaps the finest and certainly the most influential of English aristocratic estates, created over several generations by the best-known architects and landscape designers of the day. Inspired by the classical world, surrounded by vast cultivated acres sprinkled with temples and follies, it has been called a Grand Tour in itself. Yet twice in its history, and despite its fame and beauty, it narrowly escaped destruction—in 1848, when the profligate heir left the family destitute, and in 1922, when its purchase and conversion to Stowe School literally drove the demolition crew away. The last-minute rescue saved a worn-down masterpiece with the longest colonnaded front in Britain, a huge marble hall of exquisite detail modeled on the Pantheon, and the most famous Arcadian gardens in Britain.

The school thrived, in its once-grand palace. Could the importance of the house be recovered? In 1997, the Stowe House Preservation Trust was formed by a concerned group of 'Old Stoics', including two WMF Trustees—the wine connoisseur and World War II spy, Peter M.

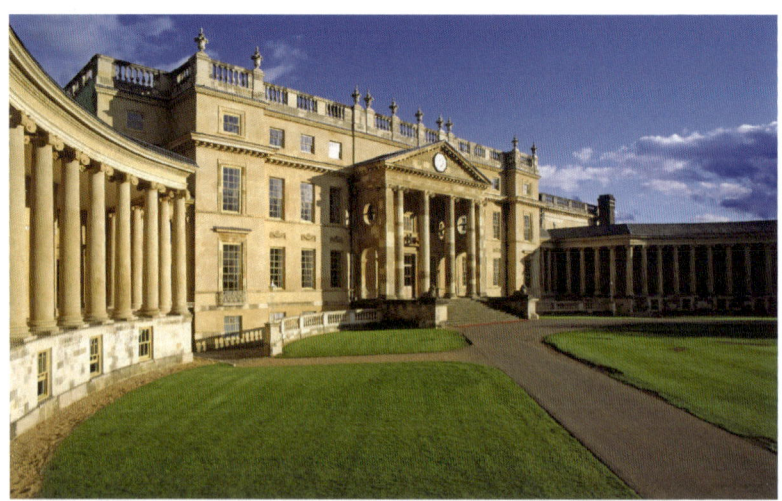

Buckinghamshire, United Kingdom. Stowe House (1680–1780), the most influential eighteenth-century house in Britain, restored by WMF and partners 2002–14.

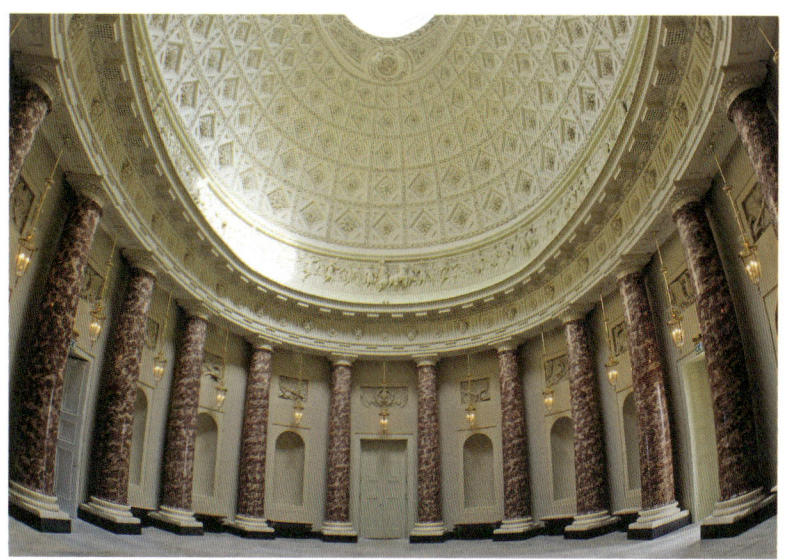

Buckinghamshire, United Kingdom. The Marble Saloon in Stowe House, restored in 2005.

F. Sichel, and the late energetic director of the National Gallery of Art, J. Carter Brown—as well as Hadrian awardee Lord Sainsbury (honored with his brothers The Hon. Simon and Sir Timothy in 1999 for the family's many contributions to cultural heritage in Britain). Stowe House was listed on the World Monuments Watch in 2002.

Funds were marshaled from many sources for incremental restoration projects. Partners for the overall preservation were the British National Trust, to which the 400-acre landscape gardens were deeded, and the Stowe School. WMF provided Wilson Challenge funds to match British contributions for the Marble Hall, and funding from Paul Mellon's estate supported the State Music Room and on-site skills training. In the later stages a major British donor, Richard Broyd—proprietor of a stately nearby hotel—stepped forward through WMF Britain, also matched by Wilson funds. Even the city of Blackpool participated, returning (on long-term loan) two eighteenth-century lead lions by John Cheere that formerly graced the 1,000-foot-long front of the house. With the replacement of 30 spun-copper urns, Stowe House was returned to its glory, a triumph of international concern. In June 2014, its completion was the first event in our 50th Anniversary celebration of World Monuments Fund.

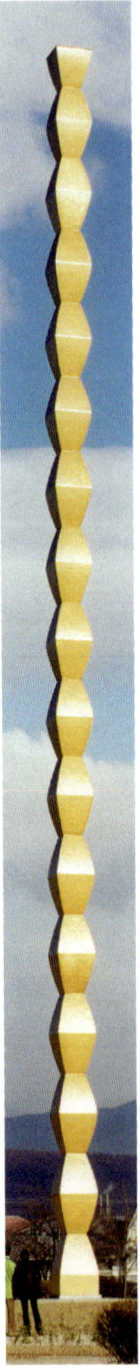

A TWENTIETH-CENTURY MASTERPIECE

Brancusi's *Endless Column* Ensemble

Another form of public display—collective, reverential, inherently moving, and also intensely personal—is the war memorial. Far and away the most original First World War memorial is also one of the marvels of twentieth-century sculpture—the magisterial structure by Constantin Brancusi known as the *Endless Column*, erected in 1934 in Târgu Jiu, Romania (near the sculptor's birthplace), to commemorate youth who died defending the city. A miracle of symbolism, engineering, and art, the column of golden modules rises 30 meters into the sky, the central feature of a long park that includes two travertine sculptures, the *Gate of the Kiss* and the *Table of Silence*. Disrespected during the Communist regime—there were attempts to destroy the column that damaged its armature—the entire complex was in sad disrepair when listed on the 1996 Watch.

WMF's leadership, in partnership with the World Bank and the Romanian government, helped resolve the technical disputes that lasted far longer than the column's actual restoration, completed in six weeks. However, conserving the other two sculptures raised the question of the pitiful condition of the parkland, for which a solution—as close to the original conception as possible —was devised by American landscape designer Laurie Olin. WMF Trustee Mica Ertegun, a well-known designer herself, has played an active role in the project—now expanded to include a visitors' center—that has revitalized a great cultural treasure in her homeland. She was awarded the 2014 Hadrian Award for the Brancusi project, and also for establishing a fund to preserve religious sites of all denominations. With her, Ellsworth Kelly—the celebrated artist—also received the Hadrian Award for his support of WMF projects around the world.

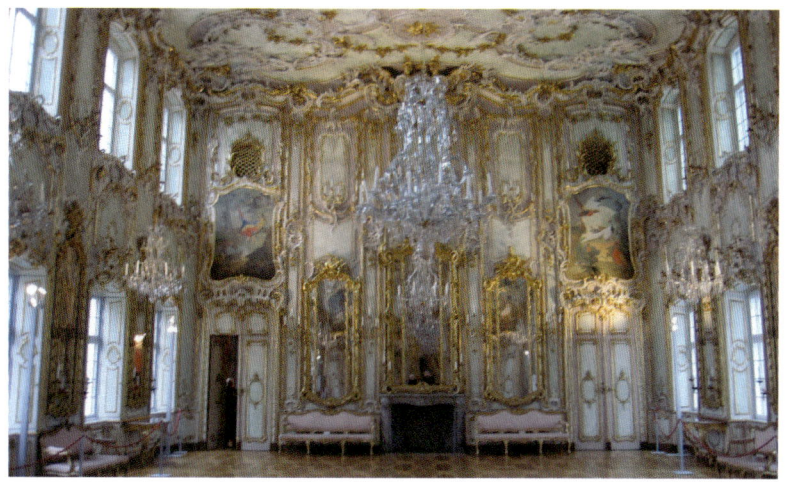

Augsburg, Germany. The ballroom of the Schaezler Palace (1765–70), restored 2003–05.

ON THE INSIDE

Fine European Interiors

On April 28, 1770, an apprehensive 14-year-old from Vienna was welcomed with great pomp in the most beautiful rococo ballroom in Augsburg, Germany, decorated in her honor and opened now to the local elite for the first time. Crystal chandeliers hung from the high ceiling, their candlelight dancing off wall mirrors with richly gilded stucco surrounds designed by famed artists from the Bavarian court. A vast ceiling fresco opened onto allegories of the four continents, united under trade and astrological symbols. Appropriately, the Roman artist Gregorio Guglielmi had also painted the ceiling fresco in the vast gallery at Schønbrunn, her former home.

The pampered guest was the Archduchess of Austria, Marie-Antoinette, en route to Versailles to marry the French dauphin (the future Louis XVI). Her host was Augsburg's most prosperous banker and this grand reception—in the beautiful room that glittered in her honor—was her last public appearance in a German-speaking land.

Now known as the Schaezler Palace, the rococo masterpiece by Karl Albrecht von Lespilliez, chief architect of the Bavarian royal court, is especially precious for having survived the devastation of the Second World War. Today it belongs to the Augsburg Municipal Museums and

Art Collection, and the ballroom—after extensive restoration by WMF and a consortium of local donors—is the jewel in its crown.

For WMF, the Schaezler Palace also shines as an example of our Fine European Interiors program, the brainchild of Bertrand du Vignaud during his presidency of WMF Europe. Government agencies are more inclined—of necessity—to step in to rescue falling buildings than to treat their interiors, no matter how exquisite. Yet the essence of a building, and its claim on history—as in the Schaezler Palace—more often than not resides inside.

In a revitalized interior in Monza Cathedral, Italy, the life of Theodolinda, a sixth-century Lombard Queen, now parades past in all the finery imaginable by fourteenth-century fresco artists. The ravishing high altar and apse of the great baroque Kollegienkirche in Salzburg (consecrated 1707), a masterpiece by Johann Bernhard Fischer von Erlach, is once again filled with brilliant sunlight, as it was when Mozart conducted the first performance of his *Mass in D-Minor*. Eighteenth-century interiors in the Hôtel de Talleyrand and an exquisite music room in the Bibliotheque de l'Arsenal have been patiently studied and reconstructed in Paris, and in Rome, as noted, we celebrated the conservation of the incomparable frescoes by Annibale Carracci in the gallery of the Palazzo Farnese as part of our 50th anniversary.

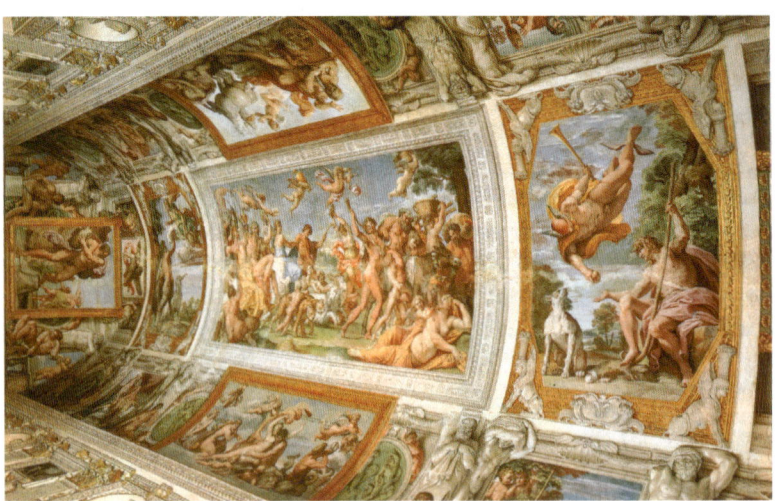

Rome, Italy. Annibale Carracci's celebrated decoration of the gallery of the Palazzo Farnese, *The Loves of the Gods* (1597–1604), **restored 2011–15.**

NOT SO LONG AGO
Modernism at Risk

Brancusi's Endless Column *complex—an indisputable masterpiece—is representative of a wide spectrum of heritage that has been greatly neglected: buildings and cultural landscapes of the twentieth century. Beginning in the 1980s with our work on modern Mexican murals, WMF has championed modernist art and architecture. More than 20 important modernist buildings have been listed on the Watch, including Konstantin Melnikov's Rusakov Club (Russia), Oscar Niemeyer's International Fairground at Tripoli (Lebanon), Alvar Aalto's Viipuri Library (Finland), the revolutionary National Art Schools in Havana (Cuba), and several sites by Frank Lloyd Wright and Richard Neutra in the U.S. We gave the name 'Main Street Modern (USA)' to representative endangered modernist buildings on the 2008 World Monuments Watch, and several benefited from the attention. Another listing on the same Watch looked at the needs of an iconic twentieth-century American cultural landscape—the highway corridor of Route 66, America's 'Mother Road' from the Midwest to California, with its quirky dinosaur diners, smart-aleck truck stops, and local-booster gas stations.*

Old Westbury, New York. The once-celebrated International Style home of A. Conger Goodyear, designed by Edward Durrell Stone (1938), nearly lost in 2002.

A LAST MINUTE RESCUE

A. Conger Goodyear House

The degree to which important Modernist buildings can be undefended is illustrated by the rescue of the A. Conger Goodyear house in Old Westbury, Long Island. Widely celebrated in the late 1930s and 1940s, the International Style house was commissioned as a showcase for his art collection by the first president of the Museum of Modern Art from the museum's first architect, Edward Durell Stone. But times and tastes changed. The owner died, his art was dispersed, the house sank into oblivion. In 1997 the property was sold for development.

The house was scheduled for demolition when it was discovered by a passionate modernist architectural historian, Caroline Zaleski, who brought it to WMF's attention. Listing on the World Monuments Watch in 2002 was the first step. A partnership was formed between WMF and the Society for the Preservation of Long Island Antiquities. Artist Frank Stella facilitated a loan from the Barnett and Annalee Newman Foundation to purchase the house on the brink of destruction. With the bulldozers banished and local and national attention galvanized—the house was listed on the National Register of Historic Places and designated as a local landmark—a new, appreciative owner was found. But it was a very close call.

CELEBRATING COMMITMENT

World Monuments Fund/ Knoll Modernism Prize

To recognize the variety and importance of our Modernist heritage, and to encourage appropriate conservation of Modernist buildings, WMF and Knoll—the innovative furniture company noted for modern designs—established a biennial prize to celebrate creative approaches to preserving or enhancing a modern landmark. Launched in 2008, the winner is selected by an independent jury headed by architectural historian Barry Bergdoll, who hosts the presentation event at the Museum of Modern Art. To date, the prize ($10,000 plus a Barcelona chair created by Knoll) has been awarded to restoration teams for their work on a Bauhaus trade school in Bernau, Germany (1929–30), a light-filled tuberculosis sanatorium in the Netherlands (1931), an elegant elementary school in Japan (1956–58), and Alvar Aalto's famous Viipuri Library (1927–35) in Vyborg (then Finland, now Russia). Both the ingenuity required of the restoration architects and the exemplary quality the work itself distinguish the award.

Vyborg, Russia. The restoration of the Viipuri Library (1927–35) by Alvar Aalto, awarded the World Monuments Fund/Knoll Modernism Prize in 2014.

WMF technical reports and economic surveys.

INFLUENCING OTHERS
Leadership and Advocacy

By the early 2000s, WMF had developed new levels of competence and reach (requiring more staff) and had moved again, to a handsome older office building on Madison Avenue and East 29th Street where we occupied an entire floor (a big plus) and endured slow and broken elevators (a big minus). We had expanded our offices in London and Paris, and were sponsoring field representatives in India, Africa, and the Near East. The fascination and hope inherent in the World Monuments Watch drew people from all corners of the earth. Indeed, in 2004, aided by the great explorer Sir Edmund Hillary, we planted the World Monuments Watch flag on Shackleton's exploration hut in Antarctica—making WMF active on all seven continents. At the same time, the Wilson Challenge helped WMF create preservation partnerships for advocacy, planning, on-site work, training, and interpretation, as needed throughout the world.

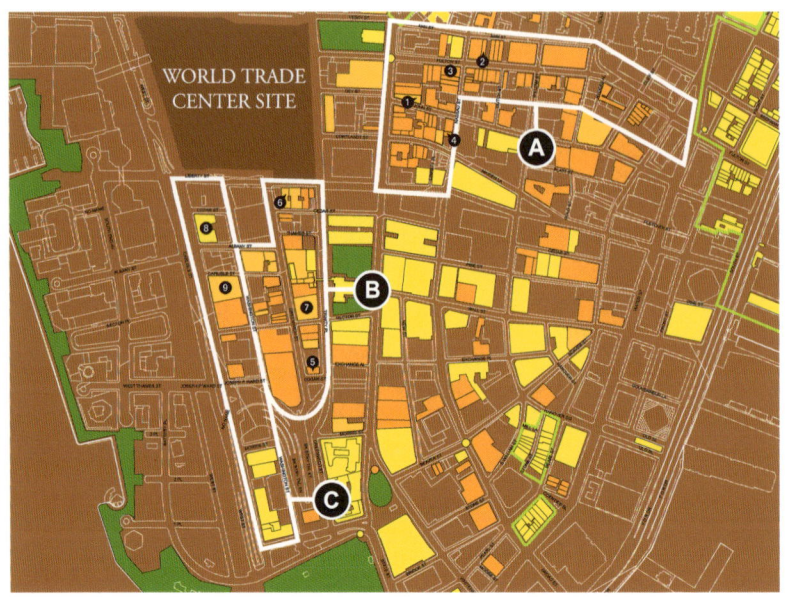

New York, New York. Historic Lower Manhattan (2002).

JOINING FORCES

Lower Manhattan After 9/11

Following the terrorist destruction of the World Trade Center in 2001, WMF was proactive in gathering relevant historic preservation agencies to create the Lower Manhattan Emergency Preservation Fund. The whole of Historic Lower Manhattan (65 historic sites in six historic districts) became an emergency addendum to the 2002 World Monuments Watch—drawing attention to the most extensive historic urban fabric in the United States and its needs for greater planning protection.

COMMON GROUND

Usumacinta River Cultural Landscape

Advocacy is a valuable tool when dealing with larger issues that affect more than a single site. Consider the famous ancient Maya cities of Yaxchilan (Mexico) and Piedras Negras (Guatemala), rivals at their height in the sixth to ninth centuries,

separated by 25 miles of dense jungles and the white waters of the Usumacinta River, now an international boundary. Fifteen years ago, both sites suffered from lack of maintenance, their extensive Maya ruins—temple pyramids, ball courts, carvings, stelae, hieroglyphs—also threatened by looting, encroaching agriculture, and forest fires. The Mexican government's plans for hydroelectric dams that would flood the region added another peril.

Yaxchilan was listed on the World Monuments Watch in 2000, followed by Piedras Negras in 2002. By 2004, they were joined in a common listing—including the archaeological territory between them—called the Usumacinta River Cultural Landscape. WMF sponsored symposia for integrated management plans focused on conservation and sustainable tourism, with training workshops and site stabilization as tools for regional development. The threat from the proposed dam to the entire archaeological area was dramatically visualized with NASA and AIRSAR technology, making the case for preserving the historic landscape.

Usumacinta River Cultural Landscape, Guatemala and Mexico. Simulation of a proposed dam on the Usumacinta River (2004) helped to protect Maya sites in the region.

POLITICAL BENEFITS

U.S. Government Funding

In the spring of 2000—I remember the trees in glorious bloom—Bonnie Burnham and I had breakfast in Washington, D.C. with Bonnie Cohen, a State Department official (Under Secretary of State for Management) with a passion for historic preservation. What, she wondered, might be done to promote attention for cultural heritage through the State Department? Burnham had an immediate answer: make funds available to U.S. Ambassadors to assign to local projects. The idea grew wings as the U.S. Ambassadors Fund for Cultural Preservation.

It is win-win. By definition, American dollars spent to improve and protect local heritage sites are a sign of approval and value. There are immediate add-ons in training, employment, education, and benefits to the local economy. The ambassador shares in the pride of accomplishment as the project advances. Visible and visitable results are a lasting benefit to the home country and to our international relations. Since 2004, WMF has helped oversee projects

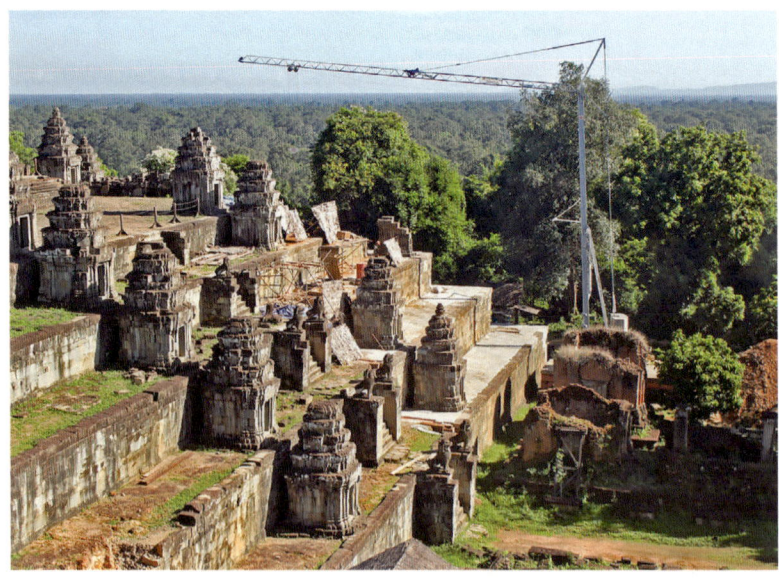

Siem Reap, Cambodia. Phnom Bakheng, one of Angkor's oldest temples (late ninth century) has received U.S. government support for restoration and training since 2008.

Babylon, Iraq. Since 2008, WMF has partnered with Iraqi authorities on documenting and protecting cultural heritage, with support from the U.S. government and other donors.

in Cambodia, Ethiopia, Ghana, Iraq, Jordan, Libya, Tanzania, Thailand, Turkey, and Zanzibar, for projects totaling almost $11 million—an invisible percentage of U.S. foreign aid, but a major and very visible demonstration of faraway America's concern for local cultural heritage and traditions. And of course our ambassadors love it.

Not that it is without a bureaucratic cost. Today the program is overseen—like everything else at WMF—by Lisa Ackerman, our Executive Vice President, whose story is another miracle of World Monuments Fund. Just out of college in the mid-1980s, Lisa was our very first summer intern, sorting out the piles of papers from the International Fund for Monuments in the basement on East 72nd Street. She moved to a real job at the Kress Foundation, where she served as my deputy for 25 years, supervising Kress grants. The KFEPP excited a passion for historic preservation, leading to higher degrees, part-time teaching, volunteer work, awards from the field, and her move to WMF in 2008. Like many others drawn to our work, she is the right person in the right place.

Col. Gray composed informative newsletters for IFM in the 1970s.

> **VENICE COMMITTEE**
> INTERNATIONAL FUND FOR MONUMENTS, INC.
> 15 Gramercy Park, New York, N.Y. 10003, USA
> S. Polo 2454 - 30125 Venezia, Italia
>
> Venice, Italy
> January 10, 1975
>
> Dear Friend,
>
> You may be comforted to learn that the Italian Government has torpedoed the baseless reports about misappropriation of funds earmarked for Venice. In a mid-December letter to the New York Times, the Italian Credit Consortium for Public Works politely termed such reports "in error", adding that the funds (approximately $550 million) "are in a special deposit account with the Bank of Italy as certified to by official records sent to you under separate cover".
>
> Already I have heard the complaint "well, then why haven't they spent this money." The answer is that a responsible agency doesn't spend such a huge sum merely because it is available.
>
> Until the Special Law For Venice was passed, the Ministry of Public Works could not justify the expenditure of the several million dollars for the preparation of a detailed engineering plan which is presently being studied and debated. For example, the measures suggested for the defense against further inundation of the city.
>
> One very interesting plan is the installation of inflatable dams at the inlets to the Lagoon. On December 12, 1974 a very impressive demonstration of this system was staged by Pirelli (rubber) and Furlanis (construction) near Chioggia where they emplaced a working model one-200th the size which would be required for the Lido channel. Under extremely adverse conditions with high winds, driving rain and high tides, a group of government officials and engineers observed as the pumps were turned on and within 15 minutes the flexible dam was filled with water. The group was permitted to walk along the deck of the dam and to observe that the water was higher on the seaward side. A short time later the pumps were reversed and the dam sank out of sight to the floor 15 feet below.

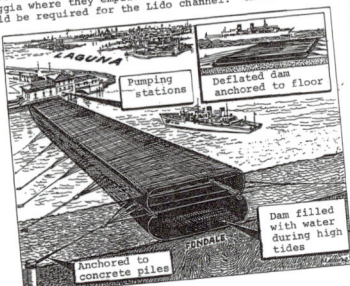

WMF's 50th Anniversary book, published by Rizzoli, 2015.

CREATING A RECORD
Communication and Publications

Describing the important things they do is a challenge for every philanthropic organization—in our case, especially so, as our cause was still new, our activities far away, and our projects often extremely complicated and expensive. Site restoration is a slow process. Just the planning can require long periods of time and many different experts, and the work in progress—often seasonal, and over a period of years—can be difficult for non-specialists to visualize. (Plus our international audience was not always English-speaking.)

But there was so much to relate!

Publications issued by the International Fund for Monuments were few. Col. Gray's bi-annual newsletter of activities and personalities was from time to time supplemented by small pamphlets describing the work at a field project and/or the art and history of a particular site. These were valuable records, but not a concerted effort to share the organization's goals and activities with a larger public. Here was another challenge for World Monuments Fund. How could this tiny organization at once present our substantial international accomplishments and attract new attention to our cause?

For the celebration of WMF's twenty-fifth anniversary in 1990, American Express sponsored a photographic exhibition and publication entitled *Saving Our Past—A Race Against Time* that dramatically illustrated how WMF worked in the field. For our thirtieth anniversary, a handsome softcover volume, *World Monuments Fund—The First Thirty Years* (1995), described all the projects and activities of the organization decade by decade and marked the transition from concentrated work on a few selected sites to the broader grants-giving/matching funds approach of the WMF/KFEPP. By 1996, with the first *List of One Hundred Most Endangered Sites of the World Monuments Watch*, WMF unequivocally stepped into the role of leading advocate for international cultural heritage. By 1999, a booklet reviewing the first three rounds of the *Kress Foundation European Preservation Program* (1987–1999) described 110 matching grants for projects in thirty-one countries.

WMF's first regular publication, *Milestones* (1995–2001), was a four-page newsletter with a red banner full of lively and pertinent information—World Monuments Watch listings, the importance of archaeological site conservation, new trustees, Hadrian Award recipients, major field projects, trips, activities of WMF affiliates, and our annual report. Looking back on it now, from an age of information overload, it belongs to another time, though its pages reflect the first international view of historic preservation.

Milestones gave way to a beautiful, glossy full-color magazine—*ICON*—issued quarterly from 2002 to 2007. Short, visually stunning pieces by informed writers described the background and challenges of selected WMF sites, plus notes on our core activities. A handsome hybrid—half general interest, half newsletter—we hoped it would attract a newsstand audience (à la *Archaeology* magazine) for cultural

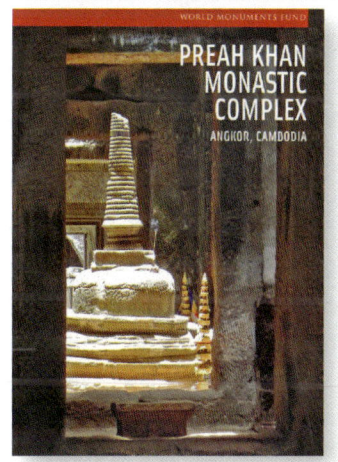

heritage and its preservation. When that failed, we acknowledged a noble effort and closed it down. In hindsight, *ICON* was doomed by the expanding Internet.

Fast-forward to 2015, and marvel at all of the information that WMF provides to the preservation field, especially the project reports, surveys, conference and workshop proceedings, training and technical manuals—several hundred in all, available on WMF's website free of charge. They are invaluable professional resources, immediately at hand.

For general interest, we issue an avalanche of brochures and other publications, annual reports, Hadrian Award programs, Knoll Prize brochures, and World Monuments Watch announcements. Also available is a series of short, beautifully illustrated monographs published by Scala on our work at Angkor, St. George's Bloomsbury, the Qinglong Emperor's Retirement Lodge, and Brancusi's *Endless Column*. These are our *bona fides*—as beautiful as the works they celebrate—and they never fail to stir the heart. But the circle they reach is small.

WMF's first book, *The Razing of Romania's Past* (1989) by Dinu Giurescu, illustrated the ruthless destruction of traditional architecture throughout Romania during the Communist dictatorship of Nicolae Ceausescu. The photographs had been smuggled out of the country at great personal risk by the author, a history professor who found his way to our door as the best hope for getting the story told. A decade later, the selection of one hundred World Monuments Watch sites described in *Vanishing Histories* (2001) by Colin Amery and Brian Curran underlined the escalating pace of cultural loss. For our fiftieth anniversary, WMF has produced a new book, guided in its inspiration and substance by WMF Trustee Andrew Solomon, whose background in realms of international art (though he is best known for his books on psychology) shines in the essay on the Qianlong Garden in Beijing. *World Monuments: 50 Irreplaceable Sites to Discover and Champion* (Rizzoli, 2015) gathers celebrated writers and photographers to look through the lens of specific sites and places (Krakow, Venice, Cairo, Rome, Agra, Cusco, Beijing, Mexico City—each standing for many others) at the effects of war and human conflict, climate change, development, tourism, the erosion of cultural traditions, the protection of delicate places, and the impact of urbanization on human heritage. It is hard to imagine how the case for WMF's work could be better made.

2015
World Monuments Fund at Fifty

In 2010, WMF moved into a wonderful new office in the Empire State Building, the iconic art deco building (1931) whose international fame is matched by the unsparing care and attention to detail of its owners, the Malkin family. Recognizing the synergy between WMF's mission and their own historic property, they have made us feel very much at home. This is Command Central for our international organization.

Historic preservation, as a movement, is roughly the same age as WMF. Col. Gray and his restless energy were part of the dawn. Over the ensuing thirty years, with the support of our committed funders (led first by the Kress Foundation and then by Robert W. Wilson), Bonnie Burnham has been the right person in the right place. Fiercely determined and dedicated, she has been capable of recognizing and defining challenges and incrementally structuring responses, within the range of limited resources, for the needs of an entire field of human endeavor that is constantly evolving. Time and again, WMF's programs ventured into untried territory (the KFEPP, the World Monuments Watch, the Wilson Challenge, training professionals in Cambodia, conservation charettes in Czechoslovakia, reactivating almost-lost crafts in China, etc.). Under her leadership, in response to the question asked in 1984, it has indeed been possible to create a professional non-profit organization to respond to endangered architectural heritage throughout the world. By any measure, it is an extraordinary achievement.

Bikaner, India. WMF Watch Day 2012 celebration.

On her retirement in late 2015, Burnham was succeeded by Joshua David, a co-founder of one of New York City's most enterprising and successful restorations, the High Line (1999–2014), which harnessed the vision and talents of dozens of agencies and individuals—landscape designers, artists, architects, preservationists, and planners—to convert a disused industrial railway into a hugely popular (and monumental) public park. He now carries these skills to the world.

Overseeing World Monuments Fund is an engaged board of trustees, chaired by Christopher Ohrstrom, a passionate preservationist and businessman expert in historic wallpapers. International and cosmopolitan, our board is composed of lively, opinionated, generous members who have traveled widely, care deeply about protecting cultural heritage, and remain active for years.

Each of us brings a personal perspective as unique as the sites we serve. Some have championed particular causes—Nancy Brown Negley in Tunisia and WMF's archives, Roberto Hernández Ramírez with Mexican projects as a Wilson partner with the Fomento Cultural Banamex, Bernard Selz with pre-Columbian sites in Latin America and European and Islamic heritage, and former Chairman W. Lyons Brown for the heritage of the United States. Jack Shear and Ellsworth Kelly established a fellowship in honor of Bonnie Burnham, Fernanda Kellogg guided the Tiffany Foundation in several projects with WMF, and Eugene V. Thaw, a Hadrian Awardee, is helping WMF create alliances with educational institutions.

Ultimately, it is the wonder of human creation—the chance to explore how those before us structured their lives for nurture and worship, for education and art and music, for communal protection and the pomp of status and power, and for death—that urges us to preserve what we can of the sites and structures of the past. The true value of the work of World Monuments Fund, over its first half-century, is perhaps best judged not in the hundreds of millions of dollars spent, the astonishing sites protected, the protocols established, the individual buildings restored, or the jobs created, but in the faces of school children on a World Monuments Watch Day outing, the excitement of experts completing a project, the passion of a Hadrian Awardee's speech, or a tourist's first visit to an ancient city. The achievements of the past are a precious support to our precarious existence; when we treasure and preserve them, we enrich ourselves.

Rome, Italy. Interior view of the Pantheon, restored by the Emperor Hadrian in A.D. 126.

As the Emperor Hadrian knew.

CPSIA information can be obtained at www.ICGtesting.com
Printed in the USA
BVIW12n1104210416
444307BV00004B/1